THE A. W. MELLON LECTURES IN THE FINE ARTS

DELIVERED AT THE NATIONAL GALLERY OF ART

WASHINGTON, D. C.

BOLLINGEN SERIES XXXV.22

THE A. W. MELLON LECTURES
IN THE FINE ARTS · 1973
THE NATIONAL GALLERY OF ART
WASHINGTON, D.C.

BOLLINGEN SERIES XXXV · 22

PRINCETON UNIVERSITY PRESS

The Use and Abuse of Art

By Jacques Barzun

Published by Princeton University Press,
Princeton and London

This is the twenty-second volume of the
A. W. Mellon Lectures in the Fine Arts,
printed here as delivered at the National Gallery
of Art, Washington.

The volumes of lectures constitute
Number XXXV in Bollingen Series, sponsored
by Bollingen Foundation.

Library of Congress Cataloging in Publication
data will be found on the last printed page of
this book.

Printed in the United States of America
Designed by Frank Mahood

Contents

The Use and Abuse of Art

Why Art Must Be Challenged

LADIES AND
GENTLEMEN:

Those of you who are readers of Nietzsche will recognize in the title I have given to this series of talks—The Use and Abuse of Art —a paraphrase of the title of his great essay of a century ago, "The Use and Abuse of History." Nietzsche was a trained historian and he was not undermining his own craft. Neither is it my purpose to undermine Art. It would be strange indeed if after a lifetime of concern and activity in behalf of the arts, I should feel a sudden whim to turn against them. What I hope to exhibit here is something very different from attack and defence—and more difficult. If one looks at Nietzsche's title in the original German one perceives his intention more exactly, and mine as well. What the German title says in so many words is: "The advantages and disadvantages of history for life." Such also is my preoccupation about art. Nietzsche goes on to speak of the worth and "un-worth" of history in relation to life. He came to the conclusion that the historical sense under certain conditions weakens the sense of life. History, nonetheless, retains its proper uses and should greatly flourish. Similarly, I shall hope at the end to assess the worth and the uses of art and invite you to judge them with me. Throughout

3

we shall be asking ourselves whether there may not be unsuspected disadvantages in both our formal and our casual absorption of art —even in our habitual modes of talk about it—all this in order to reach a conclusion about its value and its drawbacks *for life* at the present time.

I grant you that "life" is a rather vague term—whose life? What kind of life? spiritual or material or both? And life at whose expense? Think of that remark of William Faulkner's, which many people would applaud without scruple: "If a writer has to rob his mother, he will not hesitate: the 'Ode to a Grecian Urn' is worth any number of old ladies." The morals of this bravado are far-reaching. Is it right to sacrifice for art the lives that modern feeling would refuse to sacrifice for the good of the state? Perhaps. Then is it decided that art is superior to society? Yes or No? I shall try to give detailed answers to questions such as these. At this point let me say only that I have at heart the well-being of the individual who cultivates the arts as maker or beholder, no less than the well-being of the society that supports and encourages artistic production, distribution, and conservation.

These matters affect large numbers of people and involve large groups of facts and feelings; but even though the scope is broad, the inquiry ought not to proceed by bare generalities or simple abstractions. My task therefore calls for much description—to show what contemporary art is and does and how it is felt and thought about; together with much analysis, comparison, and interpretation—to show what I see as the effect of this vast activity upon life. A complete description is of course impossible, as much so as a direct demonstration of effects. I can only supply illustrative examples. These will be drawn from all the arts and from social and intellectual realities presumably known to everybody. The 4 particulars will not so much prove what I advance, as remind you

of what you know. Having had your memory of actual artistic experiences refreshed, you will be able to see for yourselves whether my interpretations fit the remaining body of facts that we lack the time to look at together.

For this procedure to be effective, I shall need the help of your imagination and sense of analogy. If I cite a work or an event that you do not know, you can obviously not bring it before your mind's eye. But as I go from example to example in an explicit context, you can surely bring up a case of your own to fill the gap of the one you happen not to recognize. That is what I mean by exercising your sense of analogy. I beg you not to dismiss one or another of my conclusions before you have looked over your own range of experience and seen whether some portion of it does or does not correspond to what I say. There is plenty of time for you to reject my views if in the end the evidence seems to you inadequate.

You may say that this heroic effort to which I invite you could be dispensed with by the use of slides. I think that to use slides would interfere with the kind of understanding I want to impart. The eye that has looked on an object in the light of certain assumptions becomes a biased witness when that object is presented in a different light for a different purpose. Again, to show certain items tends to suggest that the case stands or falls by what is shown. The pictures are taken as proofs rather than as indications among others that might be adduced. Finally, to punctuate with pictures the development of a thesis about art as a whole would unbalance it. Music, dance, theatre, poetry and prose fiction constitute a formidable segment of what we call Art, and if examples from these are to be marshalled, it can only be by the spoken word. Such are the reasons that warrant the exclusion of visual aids, though the omission adds to your philosophic strain. 5

Usually, when one speaks of "worth" and "unworth," merit and demerit in the great realm of art, one uses the words *distributively*, applying them to this or that artist, this or that work, this or that school. It is the critic's role to do this distributing of labels, and in the end the finer the discrimination of one artistic element from another, down to one detail in one corner of a painting or one word in one line in a poem, the greater the critical achievement. Such investigations belong to *art criticism*. What I have to offer you is something else, which is often called *cultural criticism*. It considers and makes distinctions within much larger wholes— culture, society, the state, modern man considered as an historical type, western civilization today taken as a unit, or entire portions of the past. So it will be here. As a student of cultural history, I shall be dealing with art primarily as a single force in modern life.

This, I know, is to regard art in an unaccustomed way. Our natural attachment to particular kinds of work or to a particular art or artist makes us very casual and vague when we refer to Art at large. And yet we find it easy to refer in just that way to science or technology or government or religion. In this familiar use of terms we do not stop to specify what religion, which branch of government, what direction of science or technology. Nor do we hesitate to attribute value or harm to the whole burden and bearing of these activities when we discuss the social or moral predicaments of the present world. In my examination of art, then, I shall always be discussing its prevailing drift, its residual impact, unless I specify otherwise. This looking at tendencies is legitimate. In our time if ever in history, all that goes with the production and reception of works of art—the attitudes, ideas, clichés, pieties, goals and methods of diffusion—applies on a large scale, has in fact converged into an organized whole: art is one great institution with a high consciousness of itself as a vested interest.

6

Still, my judgments will be a good deal less wholesale than those of critics who find nothing but solace or menace in science, bureaucracy, or religion in the lump. For even though art today is a public institution, it is an institution without a theory. No coherent thought exists as to its aim or *raison d'être*. The artists, the critics, the consumers, the middlemen are content to defend themselves, each in his sector, as a party or as a person. Looked at in the mass, their attitudes, performances, and verbalizings are unpredictable and miscellaneous. Some of their acts and feelings come from recognizable traditions, conscious or unconscious; others from a tradition turned upside down—usually conscious. Still other positions derive from catchwords borrowed from the past for a passing need in the present. Thus a contemporary painter will echo Daumier's slogan that "one must be of one's own time." As used today, the words very likely state a resolve not to be an academic painter, or not to paint portraits or objects, or imitate the Impressionist, Post-Impressionist or Cubist techniques. The slogan does not carry us much farther. What is the essence of one's own time? Revolution, reaction, retreat, escape, indifference? And what is the timely mode of expression for any of these today? There are a dozen flourishing schools; fashions move spasmodically across frontiers; all past styles and twenty primitivisms are on display: which is Us? Our own time becomes an object of research with several equally valid findings, and the catchword is useless as either rallying-cry or interpretation.

It is into this thicket of facts and ideas that we must penetrate, with the help of a little history and analytic thought. In using history I shall refer now and again to three productive moments in western civilization, all of which unfortunately are called modern. We speak of modern times beginning about 1450—the Renaissance, meaning by its modernity various differences from the

7

Middle Ages. We also refer to the modern era and date it from the French Revolution—1789 to the present. Finally, we recognize as modern ideas, modern art, modern manners those that took shape between 1890 and today. It *is* confusing. I shall try to keep things straight by saying "the Renaissance," with the meaning: 1400-1600; "the Romantic Period": 1790-1840; and "the turn of the century": 1890-1914. The last half-century, 1920 to the present hour, I shall term contemporary. We may then be able to see a little better where we are.

Naturally, where we are must also be discovered by a survey of the contemporary scene. What is it that we call art in the world around us? First of all the classics of all times and countries, that is, the objects in museums—in this great gallery for example. They range in time from ancient Egypt to the most recent year. Our libraries and our book publishers promote the literature that parallels this great span. Our concert halls, theatres, opera houses are there also to reproduce what the past created that we think great or important. The historical sense, working in hundreds of trained minds, has dug out of the past an amazing pile of works of art, which are "made available"—as we say—to anyone who shows an interest.

During the last 30 years, moreover, this accumulation of masterpieces big and little has been as it were mobilized by technology. You do not have to go to it; it comes to you—by the action of the mass media in print and in radio waves, by means of the long-playing disc, the film, and the inexpensive color reproduction. In addition, there is the push of the educational systems, which means not only schools, but museums, libraries, and so-called art centers. No longer static, these establishments are relentlessly

8

active in propaganda for art. Regularly every two months I receive from the Metropolitan Museum of Art in New York a thick illustrated invitation to partake of their "Art Seminars in the Home." In one form or another, similar opportunities abound in many of our cities. Just as the school child may find that the study-hour is suddenly cancelled in favor of a visit from the musical performing-and-lecture group called Young Audiences, so the citizen may be seduced suddenly by some offer or presentation of art in the midst of life.

This is quite new in western societies. I can testify that when I first came to this country, a little over 50 years ago, no such apparatus existed. The term art center did not exist and would not have been understood. The very word Art in the current sense was infrequently heard. Rather, people tended to pursue their preferred art exclusively. They would speak of music or the fine arts, or poetry and belles-lettres, and foregather with their own kind. These groups were small and were considered special interests. No such surprise awaited them as going to the bank and finding there an exhibit of Contemporary pictures, or going to fetch Johnny from school and finding the output of his class displayed in the entrance hall. The boy with a violin was a sissy unless he could prove himself the opposite. And the notion that a soft-drink manufacturer could sponsor a traveling art show or the government benefit in its foreign policy by flinging an orchestra or a ballet across the iron curtain would have seemed an absurdity.

In western Europe, it is true, there was a tradition of official art and government subsidy. But it was tied to a severely restricted offering; it was academic in taste and sociable in purpose. The vigorous life of new art went on outside the official precincts, but again its channels were special and restricted—anything but ecu-

9

menical. In other words, what we see now is the product of a cultural revolution that occurred some thirty to forty years ago. The Great Depression saw its faint beginnings, acknowledged in the WPA. The Second World War showed by its deliberate preservation of art and artists that the heedless destruction of both in the First World War had served as a lesson.

After the second war, the *Drang nach Künsten* got truly under way. It was aided by the accumulated disillusionment of two postwar periods. The long agony had persuaded many minds that public affairs were contemptible and vile. The only civilized existence was that which moved among spiritual things, and in the realm of spirit art was supreme. Some of these new devotees had been awakened to the reality of art by contact with other lands and peoples. Still others were drawn into cultural habits by the technological devices I have mentioned. To take but one instance, the boredom of the army camp induced thousands to read paperback books and listen to broadcast music. Very potent also was the pressure of advertising, which not only cast its usual glamour over the idea of being "cultured," but what is more important, adapted and exploited the painting and literature of the preceding century in its own displays. The mid-twentieth century was made both visual and responsive to verbal innovation by the new advertising techniques initiated around 1920.

Add to this the steady optical effect of modern architecture, furniture design, and packaging; the extension and distortion of reality by the motion picture and still more by television, and lastly the saturation of the airwaves with music regardless of time, place, or occasion, and you have the main forces that opened eye, ear, and mind in the population of western countries. Though artists and their promoters still deplore the "lack of support for the arts," the spread during the past fifty years not only of re-

10

ceptivity to art as such, but also of tolerance for it is in fact amazing; indeed, it is unexampled in the history of our civilization.

We have so quickly become used to the change that we do not recognize the extension given to the term art or its magical power to stifle doubt and second thoughts. To take examples at random, we have been treated to an exhibit of chimpanzee art in London, and Paris has given a child of ten a one-boy show. The Dutch and the Jugoslavs officially encourage peasant painting and ship it abroad. Over here, the ideal of art in the street, art on the highway, amateur art and ghetto art may be spottily realized, but it is taken as perfectly normal. On one occasion, which I attended, the Mayor of New York assembled 600 leaders of art and thought to elicit from them in small groups and all together the best new ideas for making the whole city, in the Mayor's words, a cultural showcase. One proposal, applauded by five hundred and ninety-nine people, was to have the fire houses and police stations provide space for the local showing of paintings and the amateur playing of music. There was rather less enthusiasm for distributing all over the five boroughs the contents of the great museums. But nearly everybody agreed that with a little effort communities and schools could rival in artistic excitement and output the Italian cities of the Renaissance.

That the passion for art is genuine has been shown by the public debate over certain recent decisions of the Metropolitan Museum. Letters, editorials, counter-statements, investigation by the state —the cause célèbre is front-page news, like a major political scandal. So is the death of the violinist Szigeti, and almost as prominent is the full-page report of "Candid Views by Child Poets About the World They Live In." In fact, the place of art in newspapers throughout the country has kept pace with the enormous growth of professional and amateur activity, itself encouraged by founda-

11

tion grants, innumerable prizes and awards, and scientific assurances of art's hygienic and curative virtues.

This phenomenon, which is striking by its magnitude and miscellaneous contents, is even more remarkable by the fact that it is ordinarily spoken of as if its disparate elements formed a homogeneous substance called Art. This, I say, is remarkable, but not inexplicable. For as will appear in my next lecture dealing with the emotional and intellectual antecedents of this cultural frenzy, we shall find the forerunners of the movement also speaking of Art as if it were a homogeneous substance—a spiritual balm indispensable to life. It is of course on account of that now popularized philosophy that one may speak of art as a single force. But the situation is complicated by the presence of countervailing tendencies. The newest art refuses in various ways to flow in the same channel as the old, yet it owes the public attention it receives to the old dogma of Art, One and Indispensable.

Before I go on to discuss some arguable forms of this newest art, I think it proper to disclose my temper and bias as a possible aid to your judgment of the whole subject. First, let me urge you to remember that regardless of the mode of expression, my thought on what I take up should be understood in the form "If—then"; "If you go in for *this* kind of art, you must not be surprised when *that* is the result—in society or the individual psyche." "If you consider art a religion, then you must expect that it will despise the things of this world." And so on. In short, my preferences (or yours) matter much less than the perspectives I hope to invite you to share; and since such is my temper, it follows that dogmatic statements are used for brevity only: you may always supply the doubt, the contingency, or the modifying clause.

12

So much for form. A second influence that may affect my conclusions is of a different order. It is a bias of time and place. I grew up in Paris before the First World War, and not merely in the atmosphere of the new art of the century but in the very midst of its creation. As a child in my father's house I was surrounded by the young poets, painters, musicians, and sculptors who made Cubism, concrete poetry, atonality and the rest. Varèse, Apollinaire, Ezra Pound, Léger, Gleizes, Severini, Villon, Duchamp, Duchamp-Villon, Marie Laurencin, Cocteau and many others were to me household names in the literal sense—names of familiar figures in the house.

The consequence was that the style of this new school was from the start as natural and intelligible to me as any other man-made thing—the piano keyboard or the alphabet. The paintings and sculptures that made the public stare and gasp at the Armory Show in New York seemed to my childish sense a congenial idiom. The Futurist Manifestos of Marinetti struck me as just as funny then as they are today in their recent reprinting, and the first concert performance of Stravinsky's *Sacre du Printemps* was as exciting as the hullaballoo in the audience afterwards.

This accident of birth was formative, and possibly not the worst conceivable as a preparation for an intellectual career; but it did predispose me to view earlier and later periods of art very differently from the men of my generation who grew up in another milieu. That special perspective has importance beyond my own case and I shall recur to it in my final lecture.

To return to the current scene. We have so far looked at the classical sector—recognized, gilt-edged, consecrated art—and also at its amateur offshoots. Beside it stands the whole of new art, infinitely ramified. In painting and sculpture even a short list of the names attached to schools suggests how difficult it is to ascertain

13

what anybody means by "twentieth-century art," let alone by adjectives such as *new, modern, avant-garde,* or *contemporary.* The twentieth century does begin with Cubism, followed by Futurism and Constructivism, Vorticism, Expressionism, Dada, and Surrealism. These and other -isms take us through the period between wars, after which—the deluge: we have had since: Abstract Expressionism, Neo-Dada, Pop and Op art, *Tachisme,* Action Painting, Kinetic Art, New Realism, Hard Edge, Junk Art, Disposable Art, Aleatory Art, Minimal Art, and finally: Anti-Art.

All along, too, under the original impetus of Marcel Duchamp, we have been shown happenings or arrangements designed to startle us into recognizing how conventional or arbitrary our artistic notions actually are. A few years ago, for instance, a painter in New York exhibited works done in human excrement; another exhibited molded plastic genitalia around a coffin in which he himself lay naked. A third cut off pieces of his own flesh and photographed them. A fourth made stencils of classic works in order to reproduce them by spraying canned paint on the exposed surface.

The use of new materials—such as mylar sheets—also figures in the repertory of new art, and one movement flourishes under the title of Art and Technology. For its first exhibition, at Los Angeles in 1971, some 75 projects were submitted. Of those that were completed, the most striking were perhaps Mr. Claes Oldenburg's "Giant Icebag," a huge structure of orange-colored vinyl, hydraulically operated, and Mr. Rockne Krebs's "Light-piece," a system of red, green and blue lasers surrounded by mirrors in a dark room; so that, according to the catalogue, "the lights are reflected to infinity." Light in darkness has a strong appeal. Two years ago, a rising talent from South America was given a one-man show in New York by an association to promote Inter-American

14

relations, and his main work consisted of 21 small television screens around the walls of a dark room, all oscillating brightly but showing no image.

In the other arts the range of inventiveness may not be so widespread, but the same characteristics recur, especially the effort to intermingle the sensations of separate arts as well as to make a point of elements directly drawn from life. Just as the junk artist will exhibit a broken-down icebox in the flesh, so to speak, the maker of concrete music will tape sounds from the street or a noisy factory. In Mr. Ben Johnston's "Knocking-piece" the two performers use wooden mallets to hit the piano case irregularly for eleven minutes. Meanwhile the electronic musician will use the RCA synthesizer to reproduce noise, or a computer to provide themes or forms by random operation. Composers for traditional instruments match this novelty by abandoning the usual signs for notes and rhythms and substituting loops and whorls by which the performer is stimulated to improvise along the suggested arabesques. In the latest of these scores the composer also colors the curves with crayon and thus influences the player by synesthesia. In so-called concrete poetry the fusion of sound, sight, and color occurs in parallel fashion.

As to the contemporary theatre, I need only recall to you its principal devices of violence, symbolic cruelty, and obscene language to confirm the truth about much new art that it is meant to bruise the beholder's feelings and senses, in hopes of making him into a new person of the right kind. Indeed, in the works put on by the Living Theatre, the audience was admonished and insulted from the stage and violently caressed by actors roaming the aisles, so as to stimulate an immediate reform of character along lines explicitly anti-bourgeois. On the screen, finally, and in the novel, the same aggressive pedagogy conveys messages by sym- 15

bols that are often obscure, and by pornography that is unmistakable. It comes as a pleasant variation when a young French novelist of great talent devotes an entire novel about Job to the description of a heap of manure.

You will readily think of other features peculiar to the art of our generation. Those I have mentioned are only to remind you of what stands out in the environment, side by side with the classics and with certain echoes from the age of Realism and Impressionism. This coexistence, this pluralism that marks our age in the history of art is worth reflecting on. With rare exceptions, earlier times and places were stylistically intolerant and possessive. They produced, or tried to produce, *their own art*; they put in the attic the art of the previous period; they were generally hostile to the art of another country or culture, and certainly to what they considered primitive or barbarian. With them, the correspondence between the prevailing taste and the social conditions obtained also between these conditions and the art produced. For example, an age of courtly idleness favored a decorative and erotic art and stimulated comedy for the stage. When disputes arose about art, the struggle was between old and new doctrines or between two new tendencies claiming the right of succession to the great masters. We are far from such a simple contest. Art exists on too many planes and strikes out on too many tangents to permit genuine confrontation and the triumph of a style suited to our habits.

Here, then, is a first reason for examining Art as it is practiced today. What set of conditions does it accompany and illuminate? What sort of mind does it fulfill or edify? If you are invited to see a collection of flotsam tossed ashore by the sea and affixed to deal boards tinted blue, what is the bearing of that invitation and its effect? Or again, in a great and imposing museum, why the

16

little enclosure where the visitor has to pick his way among ladders leaning at various angles? Granted that the artist's intention is often negligible and the effect proportional, it is but normal curiosity to speculate about them.

You may say that in these examples there is no avowable intention; it is a mistake to look too deep. Nowadays anything put up for seeing or hearing is only meant to be taken in casually. If it holds your eye and focuses your wits for even a minute, it justifies itself and there's an end of it. I will return to this notion of the Interesting which has replaced the Beautiful, the Profound, and the Moving. What I am bringing up for scrutiny, that if modern man's most sophisticated relation to art is to be casual and humorous, is to resemble the attitude of the vacationer at the fair grounds, then the conception of Art as an all-important institution, as a supreme activity of man, is quite destroyed. One cannot have it both ways—art as a sense-tickler and a joke is not the same art that geniuses and critics have asked us to cherish and support. Nor is it the same art that revolutionists call for in aid of the Revolution.

In short, there is here a radical ambiguity about that simple word Art, a confusion of terms and of aims that constitutes a second reason for examining the art of our time. In any case it is clear that if art has importance, it is because it can shape the minds and emotions of men. It can enlarge or trivialize the imagination. If it can do so much, it affects the social fabric as well as individual lives for good and evil.

To determine where the good and the harm come from, one must discern the intimations, the atmosphere that Art—or any given kind of art—is generating. If there are no discernible moods or 17

tendencies, or if they neutralize one another, to produce mere good-natured tolerance, then those facts too are forces at work in our midst. The influence of art, we must remember, has been greatly magnified in the last hundred years by the self-conscious attention we give it in words printed and spoken. The institution as a whole has no theory, but a large incoherent body of beliefs surrounds the production and acceptance of art. This incessant verbalizing uncovers even more confusion than the output of artists. In the intervals of going to concerts and seeing pictures and films, one is exposed to a babel of arguments about the worth and the necessity of art. What is art and what is not is of course the subject of partisan, exclusivist talk. No one can remember all the distinctions, but none of them implies doubt as to the supremacy of art as such.

Consider the caption of an elegant circular from the Lincoln Mint, which offers as its annual plate a work by Dali. It says: "All else passes . . . Art alone . . . endures." It goes on: "Today, in an age of rapid change and fleeting values, the enduring significance of art stands out even more clearly." You may say that this is the brainless jargon of the advertiser. The fact remains that to most people the foolishness of this appeal has become unnoticeable. They have heard it from so many unimpeachable sources —from Ernest Hemingway, for instance, who is quoted in another circular, this time from the National Endowment for the Humanities: "A country, finally, erodes and the dust blows away, the people die and none of them were of any importance permanently, except those who practiced the arts. . . . A thousand years makes economics silly and a work of art endures for ever."

This is the Faulkner theme amplified and giving notice to the world that everybody but the artists might as well vacate the premises. Human beings have no importance, they do not last a

18

thousand years. Art has and does. Of course, the statement about lasting is false. *Some* art survives, partly by luck. And "surviving" only means being valued and used by living people who are not artists. As for the obvious question, "What would art be about if not people, their acts, beliefs, visions, and social arrangements?" it is painful to think that a novelist of Hemingway's pretensions lacked the imagination to put it to himself and modify his absurdity.

Yet the foolishness remains an important clue to the present temper. For a long time the best critics—Ruskin was one—told the western world that a great nation would produce great art. Art would come forth by a natural reflex from high endeavors and noble institutions. The maxim was really a license to criticize the nation and its institutions. Today, being self-conscious as well as disaffected, artists have come to believe that art can do without a nation, can be produced by aiming directly at art, in contempt of society. When done, the work of art suffices for all time and mankind can be dismissed. No need to ask whether in this conception "work of art" stands equally for a Hemingway novel and a junk "sculpture" consisting of the rusty springs of an old armchair. The element of quality should not distract us from the point, which is that the doctrine of art's imperishable value rests on a self-defeating argument: we must produce and support art—at private or public expense—so as to prove ourselves a great people and leave our mark in history. But our art and our artists use art to show that we are of no account whatever and might as well not exist—unless we happen to be artists. I believe I said before that art in our time was an institution without a theory.

A second line of argument justifying art seems on the surface different from the first, but in fact shares one of its premises. I refer to the idea of subversive or revolutionary art. The principle 19

here is that the business of art is to belabor society, denounce its abuses, and help overthrow its rooted corruption by making men feel their conditions of life as intolerable. The best art even goes beyond and prepares the mind and heart for a new order. In this view the function of art is not to glorify but to reprove and re-mold, do violence so as to incite to violence. Clearly, the assumption is the same as before: art cannot be divorced from moral and social significance; but in subversive art the future interests of society replace the present interests. An example of this conviction was given a couple of months ago by the Russian poet Yevtushenko when he wrote in the *New York Times*: "... genuine art cannot be anti-people. However, genuine art must, in my view, be antibureaucratic, antigangster, antiviolence" (January 15, 1973).

For some believers in this theory, the justification of art passes easily into its opposite after the revolution. At that point art reverts to its function of mirroring and glorifying the happy status quo. The healthy society enjoys a healthy, rosy-cheeked kind of art. When we come to ask, in the final lecture, how qualified art is to criticize worldly institutions, it will be appropriate to examine also the common metaphor which calls society healthy or sick. And since art does its work within society, not outside, we shall have to ask what the prevailing artistic view of life itself contributes to the sickness or health so readily diagnosed.

The third and last role commonly assigned to art is that of lifting the suffering individual out of his misery into the pure world of esthetic fulfillment. This satisfaction is genuine, as we all know. It occurs at every level of artistic perception. The crudest entertainment takes people, as we say, out of themselves, to a better place. For the more thoughtful, high art provides an Aristotelean catharsis of the emotions. Habitual users seek through the

20

contemplation of art a world of harmony and serenity. Thus the English novelist and critic Colin Wilson tells us that whenever he feels bruised and battered by workaday duties and human contacts, he retires for a weekend with a stack of long-playing records and recomposes his soul to the strains of Mozart and Beethoven.

In such a use Art becomes a religious retreat, which is itself an ancient form of psychological healing. And as everybody knows, art is being widely used for hospital therapy in cases of mental and physical disorder.

From all these roles, uses, arguments, and justifications one large and undisputed truth emerges: art is power. It influences the mind, the nerves, the feelings, the soul. It carries messages of hope, hostility, derision, and moral rebuke. It can fight material and spiritual evils, and transmit the ideals of a community now living, long past, or soon to be born. In a word, Art is deemed universally important because it helps men to live and to remember.

But in saying that these are truths, we are saying also that Art is dangerous. It is dangerous, first, because all powerful things can be dangerous; and it is dangerous also because while we tend to venerate art as one great and good thing, its various uses are most often antagonistic: art can dignify and exalt the civilization that gives it birth and also weaken and destroy it. Art can serve the Revolution or can detach an individual from the struggles of his age, making loyal citizenship appear to him as futile and perverse as revolutionary action.

In noticing these applications of art to life, we are still on the plane of art's general action and declared purposes. But in all great societies there is also a continual warfare within the domain of art itself, an endless series of battles about money, prestige, 21

persons, doctrines, and the public interest. As we saw in alluding to the troubles of the Metropolitan Museum, government, the press, business, the law, educational, and cultural institutions soon join in. Parties and factions form, and the transcendental contemplation of art disappears in the anger and recrimination that an artistic plan or event so readily kindles—a sum of passion certainly equal to the most sanguine estimate of the peaceful pleasures men owe to art itself. Artistic institutions are not only not exempt from the ordinary hatreds and disorder; they are peculiarly liable to them by reason of the special sensibilities and energies of the participants.

I mention these facts—let me say it once again—not to denigrate art and its followers, but to complete a lifelike sketch which should replace in your minds the usual bland characterization of art and artists as uniformly benign. It was that overrated sentimentalist Albert Camus who said that "only artists have never harmed mankind." The truth is, we do art no honor and no justice when we represent it as invariably humane, heroic and disinterested in its intentions, exclusively good in its effects, and thus not subject to reproach or accountability—sacred. Such compliments, whether sincerely meant or thoughtlessly repeated, deny art the very importance which they appear to claim for it. I am not of course speaking of "bad art," that is, works which for one reason or another fail to earn the minimum of respect on the part of those who know. I am speaking of art in the usual honorific sense, and I say that to acknowledge its power entails the obligation to examine how that power is exercised and how our present blind submission to it affects in turn those who exercise it. I do not agree with Lord Acton that power necessarily corrupts. But what I cannot imagine is that a power so widely diversified and embattled as

22

art has consequences we should regard as automatically healthful like fresh air and green grass.

Two main considerations, then, warrant the present inquiry into the uses we make of art. One is the intrinsic force of art itself, which acts massively and subtly on our private and public selves; the other is the special situation and temper of the arts today—miscellaneous and militant, aloof yet demanding, serious and silly, strongly marked by contempt and self-contempt, and generally treated like a single idol of the tribe—Art. The serious beholder of our serious art is impelled to account to himself for these paradoxes, as well as to answer the obvious question—how did we get from the art of Botticelli and Palestrina to the lasers and mirrors of "Light-piece" and the wooden concussions of "Knocking-piece"? By what sequence of aims and purposes has sculpture transformed itself from Michelangelo's David to Oldenburg's "Giant Icebag"? The reasons for this historical evolution will be the subject of my next lecture.

Lecture TWO

The Rise of Art as Religion

LADIES AND
GENTLEMEN:

In my opening lecture I offered a number of reasons why the great institution and vested interest that we call Art should be examined with a view to ascertaining its usefulness and harmfulness to life, social and individual. Those reasons can be classed under two heads. The first is the very great power of Art as a medium of influence and mode of communication. The other is the unusual situation of the arts at the present time, when they appear to be in opposition to every traditional idea, feeling, and activity, including art itself.

Today I shall try to carry out my promise and furnish an account of the development by which western culture has arrived at the paradoxical point of regarding art as all-important and of seeing artists preach Anti-art.

It has long been a commonplace of art criticism that the arts reach their greatest heights when they have the good fortune to serve a religion. It is almost a convention to feel awe-struck and worshipful before the art of the Gothic cathedrals, and to generalize from this example and that of the primitive tribes and lost civilizations, in which art and religion visibly sustained each other. Much ancient art served the gods and cults of the city, where

24

hardly any distinction existed between religion and the state. In the very different conditions of the last 500 years, a longing for that simple unity has inspired the axiom about great art and fervent faith. Henry Adams won a wide posthumous audience by developing the idea in *Mont-St. Michel and Chartres*. It was not a new idea in the early 1900s, nor even in the 1890s when Bernard Shaw affirmed the connection with all the strength of his encyclopedic mind.

Where did the idea come from? And even more important, why did it come to be one of the many thought-clichés about art? The idea arose, obviously, when church and state were separated at various times and places since the Renaissance and the Protestant Reformation, leaving art to attach itself to the one or the other haphazardly and finally to establish its independence of both. In that condition of independence, according to the critics of modern secular art, it loses immediacy, universality, and spiritual depth. It becomes trivial, commercial, and ostentatious, while the artist himself is no longer an integral member of society but an outsider.

Let us look at the complaint a little more closely, for the value of religion to art can differ according to the meaning and actuality of religion. When religion denotes a common mythology, the artist by that fact gains a large repertory of emotions, meanings, and symbols. When religion also means a fervent belief within him and within the beholder, a current of emotional understanding is preestablished over and above the joint vocabulary of communication. But when the artist's religious impulse is individual only, no longer linked with doctrine or ritual, then, while faith may strengthen his hand, it leaves him to invent his own symbols, with no guarantee that they will be intelligible or moving.

The common element in these varied results of religion for art is the dedication to something greater than self, the feeling of 25

transcendence. The affinity between religion and art, then, consists in this, that the artist, like the worshipper, gives himself over to an experience so very different from those of the ordinary self that he deems it loftier, truer and more lasting. This experience the beholder can share if he is receptive to art and has the capacity to feel as well as analyze. Two persons—and more than two—can then commune through art alone in a spiritual event divorced from creeds.

This power of art to evoke the transcendent and bring about this unity is what has led artists and thinkers in the last two centuries to equate art and religion, and finally to substitute art for religion.

Although the "death of God" was not proclaimed until the mid-nineteenth century, it was implied, felt, and acted on fully a hundred years earlier, during the century of Reason, the Enlightenment. Its deism and atheism, its skepticism and materialism left many earnest souls seeking an outlet for piety, a surrogate for the *infâme* church that had been discredited. In answer to this need Rousseau pointed to the spectacle of nature. Its beauty and harmony gave warrant for the feeling of awe which he said that men experienced natively like the promptings of conscience. With that revelation Rousseau opened the way to the artists and thinkers called Romanticists, who undertook the task of reconstruction after skepticism. They did not abandon Reason, but demanded its complement. It turned out to be the religion of art. Goethe and Schiller, Kant and Hegel were among its first apostles. Like Rousseau they started from man's kinship with nature, his perception of beauty, and his notion of the ideal. The desire to grasp all three in one fused experience leads to art as supreme spiritual fulfillment, free from "superstition."

26 In Rousseau's time the relation of art to nature was not debat-

able as it is now. Art aimed at imitation, in the sense of parallel expression. The relation of art to beauty and to the ideal was equally evident. Art revealed the divine in man as nature revealed God. Artists might differ in conceiving God as beyond nature or within it or within the human breast; they might differ in being Spinozists or Catholics or Swedenborgians; none were atheists. The creative spark in themselves and the enthusiasm for beauty that it generated made them spurn doubts and denials of the kind that had emancipated their fathers and also deprived them of reverence.

Like other religions the religion of art promised the individual not only the peace of harmonized feeling and understanding but also the bliss of spiritual ecstasies. For Wordsworth and Goethe, Beethoven and Berlioz, Turner and Delacroix, great art—including their own work—produced all the effects of religious fervor —enthusiasm, awe-struck admiration, raptures and devoutness. Great artists constituted the Communion of Saints. Walter Scott, hardly an extravagant mind, writes in his *Journal* that love of the great masters is "a religion or it is nothing."

But between Rousseau and these men there had occurred the French Revolution, which by its magnitude, idealism, and patriotic passion had raised the pitch of every human emotion throughout Europe. During and after the great drama it was impossible to maintain the elegant cosmopolite detachment of the ancien régime. Artists could no longer think of themselves as entertainers or craftsmen serving the leisured. They were now the interpreters of life. Had not the revolution itself used art to rouse and instruct the masses? Its striking moments and its great figures—Napoleon towering above the rest—provided matter for countless numbers of great works, from David's drawings of those about to be guillotined to Beethoven's *Fidelio* and *Eroica* Symphony.

27

In the gifted young especially, the sense of heroic dedication had been magically restored. This atmosphere was one cause of the great outburst of genius in all the arts known as the Romantic Movement. Finding the post-revolutionary world not at all favorable to heroism, these men developed a rationale of art that is still with us, scarcely modified. Perhaps the best place to look for its first principles is an essay on poetry that Schiller wrote in 1795-96. Its title is generally given as "On Naive and Sentimental Poetry," but this is the usual misguided literalism of translators. Schiller's meaning is: "On Primitive and Self-Conscious Poetry." I ask you to pause over these two adjectives. They are the key to western cultural history from the battle of Waterloo to last week.

What does Schiller tell us? First, that modern man is split—or as we should say in modern jargon, alienated. Being divided, feeling not at home in the world, he is unhappy, self-conscious. He is always examining his impulses and goals, always, as we say, in two minds about them. He acts only by deliberation after an identity crisis that has no end. As a result, his actions become more and more instrumental, calculated, instead of spontaneous. A good instance is our present consideration of art, our asking—like Schiller himself—what is art really for? and: Do we use it right?

Schiller looks at nature, like Rousseau, and finds it free from this double-mindedness. Nature is one and harmonious; that is what makes it free. And Schiller wonders whether there is not among us anyone who is still natural, primitive in the sense of simple and childlike? Yes, there is: the genius. "True genius is of necessity simple," says Schiller, "or it is not genius. . . . It is the role of genius exclusively . . . to enlarge the circle of nature without overstepping it. . . . Genius does not proceed by known principles but by feeling and inspiration; the ventures of genius are the inspirations of a God (for all that healthy nature inspires

28

is divine); its feelings are laws for all time, for all human genera-
tions." In other words, the way of salvation can only be shown us
by the genius, the artist, because he is not self-conscious like the
rest of us. He is inspired by self-belief, which gives him power,
a magnetic attraction and control over others, like a saint or a
great leader of men.

You may think that this is no longer what the artist tells us
about himself today; he is not simple and self-confident. I agree.
We shall shortly see how the change came about by a natural
evolution of the cult of art to which we still adhere. Let us con-
tinue with Schiller. Still describing genius, he makes in passing
a notable remark: genius, he thinks, is intelligent and modest and
always true to itself, but not *decent*, "because corruption alone
is decent." Then Schiller names Dante, Raphael, Dürer, Cervantes,
Shakespeare, and Fielding among others, as confirmation of that
passing remark, which we may modernize by saying that genius
is never bourgeois and respectable. In that conviction lies the
origin of the war between artist and society.

Schiller was not alone in his preoccupation with a theory of
art. In the very year of Goethe's *Faust* and five years before Schil-
ler, the philosopher Kant had shown that for art to be great it
must seem a spontaneous product of nature, born not willed; and
for this to happen genius is necessary, an original power freed
from the restraint of inherited rules. With similar words and more
explicitly religious metaphors, Wackenroder, a young poet of
24 who died a year later, asserted that the artist works by divine
inspiration literally understood. There are no such things as the
secrets of art; art is a miracle of spontaneous creation. The very
title of Wackenroder's essay expresses the new piety about art:
"Effusions from the Heart of a Friar Enamored of Art" (1797).

In Hegel, it is true, philosophy occupies a higher place than 29

art, but art, religion, and philosophy are alone together on the highest plane, each an aspect of divine worship in the service of truth. For Hegel the fundamental reality or Absolute is first conveyed through art by sensuous means, then caught up in religion and finally in philosophy, becoming purer and more abstract on the way up. But in Hegel's early thought the artistic mode was not separate from the religious. The division came later, as the notion occurred to him that when art is most successful, most truly Romantic in fusing thought and feeling, art paradoxically fails to quench spiritual longings. The reason is that the ideal lies forever beyond the senses; it is inexpressible; so art can only point in its direction. This conclusion is for us doubly interesting. First it suggests the mystic's desire for direct union with God, without the intermediary of religious forms, let alone artistic. And again, Hegel's afterthoughts forecast the very evolution of art from the time it assumed the role of religion. I mean the drive toward more and more abstract, disembodied forms to signify the ineffable; in short, art repudiating nature and the senses like religion itself. What Kandinsky or Mondrian says about his aims and his work corresponds to Hegel's "purification" of worship. The same thing was proclaimed in Hegel's own day by Blake, whose figurative art results from the conviction that nature and the senses are a veil that conceals the divine.

Art, then, is the gateway to the realm of spirit for all those over whom the old religions have lost their hold. Most Romantic artists needed nothing higher. Art was sufficient and supreme. For a Goethe or a Berlioz, nature and art equally embodied the divine. They were connected realms. The genius, as in Schiller, was nature's mouthpiece and the products of his art were an *enlargement* of nature, both alike deserving adoration.

30 These propositions seem to us emphatic, perhaps, but not

strange. Yet the contrast is sharp between them and former ideas about art and religion as well. To begin with, it was a novelty in the nineteenth century to think of religious feeling as a separate part of the human make-up, a faculty that might find its proper object here or there. Religion had formerly been but an aspect of a total belief that merged together the history of the world, physics, ancient customs, and the established political state.

Art acquired its emotional autonomy about the same time as religious feeling, giving currency to the new idea of "the esthetic." Until the late eighteenth century there was no history of art, only the lives of artists. Esthetics was first made a subject by Baumgarten in 1750 and the earliest proposal for a museum dates from only three years earlier. It was then also, in Fielding's *Tom Jones*, that we find the first hesitant use of the word creation as a simile applicable to a work of art. Until that image of man as creator became established, the arts could hardly be conceived as forming one thing—Art; for only a creator can give unity to objects that are visibly unrelated. The genius of creation and the creations of genius had to be believed in before Art with a capital A could arise. That these beliefs were foreign to a cultivated man such as Lord Chesterfield, brought up in the earlier tradition, is shown by what he wrote to his son in 1749, words that no man would have wanted or dared to write after 1800: "Sculpture and painting are very justly called liberal arts; a lively and strong imagination, together with a just observation, being absolutely necessary to excel in either; which in my opinion is by no means the case with music, though called a liberal art, and now in Italy placed even above the other two: a proof of the decline of that country. . . . The former [are] connected with history and poetry, the latter, with nothing that I know of but bad company."

As for the role of literature just before its spiritual rise, it is 31

tersely put by Dr. Johnson when he says that the "end of writing is to enable the readers better to enjoy life, or better to endure it." The charm that music has to soothe a savage breast had long been known; it was therapeutic and a pastime; the pleasure of looking at pictures or collecting them lay in the recognition of the artist's technical skill, or the revived memory of past scenes, moral precepts, and historical truths. Genre painting exercised the fancy and the domestic sentiments; portrait painting—to quote Johnson again—was "a reasonable and natural consequence of affection."

In antiquity, when Hellenistic civilization had developed a sophisticated taste for collecting and treasuring art, there does not seem to have been much awareness of its intellectual value, let alone spiritual. Execution and invention were admired, but *idea*, though doubtless perceived, was not consciously grasped. The famous statement that Phidias, the sculptor of gods and goddesses, must have been taken up to Olympus to live among them was but a poetic conceit. As for the work of poets and dramatists, its ostensible value was informative and moralistic.

When in the Christian era art began again to serve religion, its use was likewise illustrative and instrumental. The colors in a painting often had symbolic meanings. Here for example is a twelfth-century bishop writing to an artist: "Adorning the ceilings and walls with varied work and diverse colors, you have in some way exposed to the eyes of the faithful the Paradise of God, decorated with innumerable flowers. You have succeeded in letting the Creator be praised in creation and in showing God to be admirable in his work." Just try telling a modern artist that his work is adornment and decoration and you will shortly be told that you are an ignoramus about art.

32 The changed attitude since the twelfth, and much more since

the eighteenth, century does not, of course, mean that earlier men were not profoundly moved by great art. We have ample testimony that they were. We know moreover that the most primitive tribes fashion works that cause them to exult, worship, or be terrified, according as these animal or human forms are believed to embody gods or evil spirits. But such strong emotions were not at first, and only gradually came to be, ascribed to art alone. Nor was it until the last century that the making of art began to confer upon the artist the attributes of a seer and prophet, a transfer of credence and veneration that affected in its turn the reception and interpretation of all subsequent art.

To sum up, it required the Renaissance glorification of man, the scattering and weakening of creeds by the Protestant Reformation, and the general unbelief caused by the progress of science, before art and artists could achieve their present position in the world of intellect. The goal and spur of religious faith had to be removed from the other world to this world. God had to be withdrawn from eternity and rediscovered in nature or the human breast. Then and only then was it conceivable that immortality should reside in a work of art, as Ernest Hemingway told us that it does, and as every educated person is now disposed to believe.

The consequences of this shift for the artist and for society have been many and incalculable. The artist as genius, seer, and prophet bearing revelation could no longer be subordinate to the beholder and consumer of art. They exchanged places, at first in theory only, but more and more effectually, until by now everybody concedes that it is the artist who has the right to be *demanding*. We sit at his feet to learn; no pains are too much, his oracle being often obscure. Always "ahead of his time," he leads mankind. It is not merely a question of seeing farther into the future; it is the present also that the artist understands better than others. We

33

wallow in conventional lies, but he hears what nobody says and expresses our unconscious truths. As Shelley explained in his "Defence of Poetry," poets are "the unacknowledged legislators of the world." He meant by this phrase that all advances in intelligence, sensitivity, and morality have been made by genius and bodied forth in art until the crowd perceived and responded.

This power possessed by genius, as we heard from Schiller, lies in his being whole, uncorrupted, and hence not "decent." He tells the truth like a child, undeterred by respectability. Inevitably the artist stands apart. Like the Shaman of primitive religions, he is lonely and avoids the routines of life, protecting by isolation his mysterious powers, which would harm ordinary men. Curiously, as with us, this wonder-worker is held superior to the chief of the tribe.

But how can the spirituality of art be demonstrated? Quite simply by what we call its magic. Art proves the inadequacy of all materialistic explanations: in art the force and quality of the effect are out of all proportion to the cause. If the arrangement of material particles accounted for spiritual results, colors and lines and words and sounds would invariably have the effect to which we testify when we are shaken to the core by an artistic experience. Since this is not so, there is more in art than what is presented to the senses. Nor is it any pleasant or skilful collection of lines or sounds that moves us, but certain ones only. And we can but wonder how a Beethoven or a Cézanne conveys to those duly attuned the precise contours of a reality which the artist does not so much find as create. If the devices of art were material only, they could be analyzed and reduced to formulas enabling any well-trained person to reproduce the magic at will, like an engineer. The great works, moreover, would strike everybody alike; and none of this is true. The philosopher concludes that art is a miracle and a mys-

34

tery, like energy itself; that a given work is a world, self-contained and independent; and that our free use of the word creator for artist is justified.

This title of creator, repeated for over 100 years, finally raised the artist to a unique status, not always in actuality, but in general theory and historical retrospect. The great dead artist, we say, towered above his age and was or should have been recognized as its spiritual master. Now, as soon as that relation becomes accepted and talked about, the artist begins to develop self-consciousness about his "religious" role, which he thinks ought to be matched by social influence. This is the point where he loses Schiller's required quality of simple, spontaneous force. He is a child no more, because he has learned about himself. Rather, like a Hebrew prophet fulminating against the established order, in it but not of it, his mission is to moralize the world.

He does not preach the accepted morality, which is only conventional sham; he preaches the higher morality of art. What morality is that? Its details change in every generation, but fundamentally it is the repudiation of utility. The practical, the useful is the cause of all hypocrisies, arising as they do in the pursuit of material ends. The belief that art exists to vanquish matter and penetrate beyond is like the old religious faith in its denunciation of riches, business, politics, and war. On this point, Blake is an eminent witness. His engraving of the Laocoön Group, done in 1820, is inscribed with a number of sentences, half a dozen of which may be brought together to form a complete creed:

"The Eternal Body of Man is The Imagination, that is, God himself. . . . It manifests itself in his Works of Art. [i.e. man's]

Good and Evil are Riches and Poverty. Where any 35

view of Money exists, Art cannot be carried on, but War only. . . .

A Poet, a Painter, a Musician, an Architect: the Man or Woman who is not one of these is not a Christian.

Christianity is Art and not Money. Money is its Curse.

The Whole Business of Man Is the Arts, and All Things Common. . . .

Art is the Tree of Life . . . Science is the Tree of Death."

The doctrine has a familiar ring to those who have listened to the rebel young in these latter years. At the 1968 demonstrations in Chicago, the main group uttered a program in 25 articles of which two were: "The abolition of money" and "Every man an artist." They did not go to Blake: it came to them out of the "art epoch." In the century and a half between Blake and this recent Credo many other phrasings have been given to the same other-worldly absolutes. The doctrine of art for art's sake, for example, is a less oracular wording of Blake's religion of art. One finds it full blown, with all its side-thrusts, as early as 1835. It occurs in the lively preface that the French painter and poet Gautier wrote for his novel *Mademoiselle de Maupin*. In it, besides proclaiming sexual emancipation, the artist declares war against the bourgeois, the philistine. By Gautier's definition, the bourgeois is stupid, stubborn, crass in emotion, selfish in behavior, totally insensitive to beauty, passionate only about the useful and the profitable. Gautier, of good bourgeois origins, dissociates himself from the bourgeois world, and indeed from any world but that of art. He says that between a poem and a pair of shoes he would choose the poem. That choice defines the quality of his soul, establishes his

36

right to be an artist and to despise society. The bourgeois, he says, is fit only to manufacture chamber pots.

Twenty years later, it was the same Gautier who, in his last volume of verse, launched the poem that fixed in the common mind the Faulkner-Hemingway idea that only art survives and all other work is negligible in camparison. As given in Dobson's paraphrase, the key stanza reads:

> All passes. Art alone
> Enduring stays to us;
> The bust outlasts the throne,
> The Coin, Tiberius.

The dogma that daily life is trivial, coupled with a denunciation of those who do not agree, has been repeated innumerable times by artists and their advocates, not with regret but with scorn. In short, the burden of social alienation that aggravates man's spiritual alienation is not a new discovery. It coincides with the aggrandizement of art and it did not wait for Karl Marx to graft it on to capitalism. In his native Germany, the young followers of Hegel in Berlin had found out that the master was in fact an atheist, and that self-consciousness required the negation of everything that exists. It was a preview of history: they debunked love, literature, science, society, and art itself. The true communist and atheist must denounce the intolerableness of conditions in both heaven and the world, to prove the necessity of revolution.

Some went into radical politics; others withdrew into art or religion. So acute was the disaffection from the world even before Marx and the young Hegelians that Heine, writing in 1833 about Goethe's death, blames the poet's followers for ushering in an 37

"art epoch" that he rejects. Heine was a poet too, not a philistine, and he admired Goethe. But good sense compelled him to argue that the real world has a right to exist and in fact "must be given priority." The Gautier-Hemingway thesis is easily refuted by pointing to the fact that there must be a solid world of food and shelter before novels can be written and pictures painted; Gautier himself had used up a good many pairs of shoes before he ever read or wrote a poem. Therefore the "choice" he pledges himself to make between them is only symbolic pretense. Shelley's well-trained and well-balanced mind also perceived and argued for the primary necessity of living before prophesying and legislating for mankind.

But such rebuttals had no effect. Art, embodying spirit and the yearning for perfection and paradise, had too much momentum. The primacy of art, restated ad nauseam, became so self-evident that it furnished the motive power of social subversion in either of its two doctrinaire forms. One rejects the world, saying that the life of art is the only one worth living; the other rejects the present world, saying that man is heading toward a radically new order. While Gautier is giving up shoes for poems, his fellow-poet Lamartine foresees a different destiny for poetry: "It will be philosophical, political, and social, in keeping with the times that lie ahead." And again, in extremely modern words, Lamartine tells another writer that he "must be responsible, active, committed (*engagé*)."

As early as 1837, then, we have the revolutionary artist and the transcendental artist fighting side by side. Their voices have rung in chorus ever since, because their common religious task is to repel the world, with or without the zeal to remake it. Except for brief interludes when science has been conspicuous and has seemed to promise intellectual and spiritual aid, the leading minds of west-

38

ern civilization have done their work in an "art epoch." Even now, despite the rebellion against high art, the present age as a whole assumes without question that man's loftiest mode of expression is art. The models of human greatness are not the soldier, the statesman, the divine. They are occasionally the scientist and persistently, pre-eminently the artist. You remember my quoting Camus's conviction that "only the artists have never harmed mankind." One of the decisions I shall invite you to make is whether Camus or Heine is right, for upon this verdict will depend your judgment of the uses to which art is being put and your possible conclusion that art, like other things great and good, may occur in excess, may be used destructively, may intrude in the wrong places.

Before you pass upon such matters, you must review in summary fashion the rest of our spiritual and social history since 1789. If in Gautier's anti-bourgeois manifesto you look beyond the rebelliousness and schoolboy showing off, you must admit that starting from his premises the artist's attack on the world of business and politics is logical. If art is a religion, it must become the moralizer of men and monitor of life. The same holds true if art is the measure of social justice. Art inherits all the duties of the church. The artist is first prophet calling down heavenly vengeance, then priest dealing out anathemas and penances. On these points, the career of John Ruskin is a ready-made demonstration. An artist and art-critic, he began by crusading for the great master of the then avant-garde, J. M. W. Turner. With original, but now usual, forms of invective Ruskin tilted against the blind and the stupid who decried or neglected his demigod. All previous painters had to be wrong so that Turner might be right. Next Ruskin took on the whole British nation to make it accept the Pre-Raphaelites, again by proving the public wrong. He travelled up and down the

39

islands to tell the industrialists that he had nothing but contempt for their buildings and their manufactures. They were incapable of good architecture because they were not honest and noble; only a great people produces great art; art is the index of social health. But the English were money-mad, unjust, and spiritually rotten. So saying, Ruskin finally turned political economist and set up the guild of St. George to show how society must be recast if justice and art are to flourish.

Though not all the social reformers of Ruskin's century evolved their programs by way of the religion of art, other thinkers came to art through the defeats of reform. Early in the century, the failure of Saint-Simonianism furnished some examples. At the midpoint and for the continent of Europe, the disaster of the 1848 revolutions led to the same results. That four years' war shattered the hopes of artists and common folk alike. In the ensuing despair the majority seemed to turn cynical, to embrace crassness, the blind use of force and sensual enjoyment. The so-called *Realpolitik*, the Second Empire style, the literal Realism that relished the commonplace and the sordid—all expressed a deep disillusionment. A sensitive soul like Matthew Arnold wondered what was left to "prop his soul" and all he could do was remind himself of Goethe's teaching:

> He said "The end is everywhere!
> Art still has truth, take refuge there!"

That Goethe had not actually predicted "the end" does not matter. The point is that in 1850 Arnold counseled refuge in art.

The gloom of the times brought about the discovery of Schopenhauer, whose philosophy, elaborated much earlier, seemed to

40

verify the inevitability of evil. Small comfort, but Schopenhauer, the spiritual master of Wagner and Nietzsche, also confirmed the truth of the religion of art. He taught three generations that only in the contemplation of art is the restless will of man at peace. Music, as the least material of the arts, affords the truest surcease for the pain of existence—a maxim still followed by the world-weary young of today when they retire for solitary weekends with a stack of long-playing discs.

Nevertheless, in the intervals of retreat, some of the apostles of art continued to carry the war into the enemy's territory. Having defined poetry as the criticism of life and culture as the only savior from anarchy, Matthew Arnold went on to name the vice that blighted each class in English society—the upper class were barbarians, the middle class philistine, and the wretched working class subhuman. Culture was the only means of re-humanizing all three. For other diagnoses and remedies, turn to Baudelaire's poems and prose pictures of Paris "spleen" and hear him alternately preach art and drugs. In the novels and letters of Flaubert you find the same exhalation of disgust, the same exaltation of art. Had his novel *L'Education sentimentale* been understood, he thought, it would have saved France in 1870. Meantime, the artist's sensibility is violated by everything he encounters; men and things are vile, and the bourgeois world must perish, because it is not beautiful and just, as the poet and seer can envision it.

And it is true that the world was no longer beautiful. Industrialization meant uglification, seemingly without end. Nature had turned sooty and black, and so had men's clothes. Painters fled to the countryside to create images of stillness and beauty as antidotes. When they stayed in the cities, like Doré and Daumier, it was to render the contemporary scene odious by caricature and 41

stark portrayal. Still others, such as the Pre-Raphaelites, hoped to rebuke the hard commercial mind by stern allegories of moral and physical beauty.

To the eye of the artist, much more than to the clerical moralist, Victorian respectability and conventional morals were shams hiding vast social sores. Life was crushed under "the system." But note again that "life" is a highly charged word. What the artist denounced was the existence led by the masses and classes. Life, real life, was that which art celebrated and embodied, and it could not thrive in the world as then organized. The heroic efforts of the great, unrecognized, misunderstood artist to keep alive proved that society was the determined killer of spirit and truth. The City of the World was permanently at war with the City of God.

Nor was the issue solely ethical and economic. The religion of art was more demanding than any that had gone before: it applied not only moral and spiritual standards in its universal male-diction; it also applied esthetic standards. Echoing Schiller without knowing it, Ruskin says, "Taste is not only a part and an index of morality—it is the ONLY morality." And his *Seven Lamps of Architecture*, his sermons in the *Stones of Venice*, like all his discussions of ornament, workmanship, and public taste preach the oneness of the good and the good-looking.

The greatest agency for enforcing that rule was the novel. It is perhaps no accident that the early prototype of the novel, *Don Quixote*, begins by ridiculing its hero for his appearance and later for failing to see with accuracy and taste. The novel as a form, which apes that of history and biography, was providentially suited to the needs of an age when nothing and no one could escape being tested by the ideal perfection of art; for the novel made it possible to mention any triviality whatever and make it

seem profoundly suggestive. It would be interesting to search through all the novels published since Jane Austen (at the risk of eventual suicide) and list the moral and *esthetic* requirements laid down in these myriad narratives. Think of all the dull land-owners and pompous businessmen and low shopkeepers who have large ears or a coarse laugh or red hair on their knuckles, and who are to be detested as much for those ugly features as for their ugly souls!

In the novel, too, the preoccupation with the artistic setting of life was insistent. The naive old habit of perfunctorily mentioning gold plate and costly furnishings of curious workmanship was replaced by detailed critical descriptions of dress and furnishings —color schemes, choice curios on chaste mantelpieces, paintings by the right masters and statuary of the best period. The whole duty of man lay in the choice of his surroundings, his garden, and his wife, who ultimately was required to have "fine bones" in her face, whatever else she might lack.

Novelists varied, needless to say, in their use of these diagnostic traits, but the esthetic demand is unremitting from Balzac to Henry James, Proust, and beyond. Midway, the work of the Goncourt brothers, themselves art historians and collectors of rarities, exerted great influence in preparing the time of estheticism par excellence, the 1890s. The Goncourts went so far as to invent what they called "artistic prose" (*prose d'art*), the earliest tampering with syntax to differentiate "artworks" from the despised stream of ordinary discourse.

In such details as these we detect the educational effort which has been the most persistent characteristic of modern art down to the present. Artists will tell you that their works are not in the least didactic or moral. They are sincere in saying so, because by moral they refer only to conventional habits and the teaching of 43

the cardinal virtues. Nonetheless the arts of the modern period have carried on an explicitly moral and sensuous education of the public. The novel, as Balzac said, was meant to be a complete "zoology" of human types and their habitats, and from the novel the young of every generation have learned all they know about life, which includes what they should value in it. Music and the plastic arts, meanwhile, have striven to shape the sensibility to continuously changing patterns. Every school has worked to a common program: "Educate the eye, force the public to hear, uproot the academic taste." Berlioz summed up the achievement of a whole age when he wrote about his "Thirty Years' War against the professors, the routineers, and the deaf."

It was obviously the professors on one side and the deaf routineers—the bourgeois public—on the other, who needed the most intense pedagogic effort. To sustain it, the attention of all thoughtful persons had to be always bent upon the importance of Art, the blessed meaning of Art, while these docile people were also being seduced by the dogma that art rewards only those gifted and graced to receive it in proper religious humility, head in hand at concerts, slit-eyed in galleries. The sense of being "we happy few"—who appreciate Impressionism or Atonality or any newest art—has recreated the bliss of the elect, those who are called *and* chosen.

It is easy—too easy—to dismiss that phenomenon by calling it snobism; such hostile interpretations leave out ten motives to name one. The eagerness of the artistic faithful to be right should not be put down to more vulgar causes than we assign to the religious faithful in the ages of belief. The equivalence of art and religion is a fact. A believer such as Cardinal Newman observed it. An atheist philosopher such as Santayana says the same thing though reversing the terms: "Religion," he says, "is a kind of po-

44

etry whose dogmas are symbols of truth imaginatively enforced. Religion and poetry are identical in essence and differ only in their practical links with daily life." Another writer who devotes a book to comparing Art and Religion begins a sentence: "In the modern church—the cinema. . . ." He is confident that all great art is religious in that it creates meaning out of personal experience, and he speaks of "the priest-like tasks of painters, poets, and musicians." Van Gogh was of the same mind. "To try to understand the real significance of what the great artists, the serious masters, tell us in their masterpieces, *that* leads to God."

If such an interplay of terms is to be tolerated by the critical mind, religion must be given a very wide ambit and its contents taken as indicative rather than verifiable: transcendence, the ideal, the world of the Imagination, the purity of esthetic perception. And still more important is what "religion" so conceived opposes. It denies the positivist, reductive, palpably material interpretation of human life. It despises the thoughtless, ordinary, sensual acts of daily existence. Art claims all the best moments. Thus a contemporary painter, recalling his early days of friendship with the late Reginald Marsh and his wife, remarked casually that they had toured Europe and "spent religious time at the Prado and the Louvre."

The expression is a metaphor, you will say, and one should mistrust metaphor: it so easily deceives by impersonating literal truth through repetition. At the point we have reached in the story of art's assuming the guise of religion this mutation of metaphor into truth is about to take place. We have reached the eighteen-nineties, and find there a galaxy of exuberant young men working at the overthrow of Victorian morality. Once more, the chief weapon—as in the Romantic overthrow of the eighteenth century—is art, strengthened by the many battles fought in the 45

interim and the growing support of an art-struck public opinion.

But something new is to emerge from the fresh struggle. The affirmative side of the artist's religious language is no longer startling. It has become virtually a cliché. By 1908, in Shaw's play *The Doctor's Dilemma* the painter on his death-bed recites a credo that could surprise only a very provincial audience: "I believe in Michel Angelo, Velasquez, and Rembrandt, in the might of design, the mystery of color, the redemption of all things by Beauty everlasting, and the message of Art that has made these hands blessed. Amen. Amen." To the new vanguard this is too tame. Reconcilement through beauty is almost bourgeois complacency. It damns the world too indirectly. The war against the bourgeois, the infidel, the hated Turk at our gates must reach a new intensity. It will be my task next time to describe how the religion of art turned into an Abolitionist crusade; and how ever since then art and artist have not ceased to perform as destroyers.

46

Lecture
THREE

Art the Destroyer

LADIES AND
GENTLEMEN:

At our last meeting, my purpose was to give you an account of the rise of art as a religion in the nineteenth century. By showing how Art came to be regarded as the supreme expression of man's spiritual powers, I was able to explain how at the same time Art necessarily became the ultimate critic of life and the moral censor of society. At the end of my lecture I said that I would next discuss the final phase of this claim and this duel, the phase of Estheticism and Abolitionism which fills the quarter century 1890-1914. I call it final because that span of years is the formative period from which all our present ideas and attitudes are derived. By examining it with our present situation in mind, we can understand the means and the goals that have made Art the enemy within, bent on destroying the house.

These last two propositions may shock you into skepticism. That the contemporary world—since 1920—has merely amplified and multiplied what the nineties and early 1900s first achieved, I must ask you to take on faith. We lack the time here to survey the whole evidence, which is overwhelming. You may, indeed, have come across recent studies of the Cubist decade which support my view. Let that one body of fact and opinion suffice, to-

gether with the reminder that a long list of inventions and activities, from flying machines and motion pictures to skyscrapers, psychoanalysis, and organ transplants, and from the concentration camp to the strip-tease, date not from *now* but from *then*. I shall suggest later on why western civilization has not had a new idea in fifty years.

My second point follows from the first: the adversary position of art toward society reached its apogee in the late eighties and nineties of the last century. Art in the earlier time had, as we know, criticized and preached, hoping to moralize the world; the closing decade ended by giving it up for lost. The shift is natural enough and the warning signs of it came before the actuality. While Flaubert was writing his last novel, which was to devastate human society, he wrote that "to dissect is a form of revenge." Hate and revenge, you will remember, were already the ruling emotions of the "Freien," who flourished in Berlin after Hegel. Their motto was "Everything that exists is dung." But they were swallowed up in the revolutions of 1848 and the triumph of their temper had to wait for another day.

Its opportunity came when the religion of art had made enough converts to be more than a strict sect; I mean, when it was no longer necessary to be a true and qualified devotee of art in order to side with its position. The disenchantment with industrial progress, the distaste for the new democratic tone of life, the technical criticism of mechanistic science—all made recruits for the party of art; so that when the gloom of Realism and Respectability began to seem a nightmare that would never end, the awakening and revolt came about in the name of Art. It was the artists of England, France, and Germany who found the slogans and struck the attitudes by which Victorianism was debunked and destroyed.

48

A full account of that massive campaign is impossible here, but you will recall its character if I remind you of some names and some striking incidents in it. Ibsen and Nietzsche, Swinburne and Walter Pater, Oscar Wilde and Bernard Shaw, George Moore and Rémy de Gourmont, Samuel Butler and Anatole France, H. G. Wells and Henry James, Zola and Romain Rolland, Clive Bell and Roger Fry were the General Staff of an army of propagandists spontaneously gathered at the turn of the century.

The strategy was to represent art as the core of reality, by which all other things were shown false and artificial. The tactics were ridicule, exaggeration, and what I may call systematic inversion. Oscar Wilde and Shaw were the great masters of these devices. In his superb farce, *The Importance of Being Earnest*, by a simple pun on the name Ernest, Wilde disposed of an emotional attitude that had been compulsory in England since the Great Exhibition. In his essays and epigrams, he affirmed that only the commercial classes need morality. Artists live by a different code, that of beauty and perfection. One does not ask if a book is moral or immoral, but if it is well or badly written. If the artist-poisoner Wainewright wrote good prose, it more than atones for murder. "Poor life!" says a character in one of Wilde's dialogues, "Poor human life! . . . Life is terribly deficient in form." And after hearing some splendid rhetoric about Dante, the other asks: "Life, then, is a failure? . . . Must we go to Art for everything?" The reply is: "Yes . . . for everything. Because Art does not hurt us. . . . Through Art and through Art only can we shield ourselves from the perils of actual existence."

The application to society is not left to be inferred. The expositor goes on: "All art is immoral." Morals are for the practical purposes of society, which are negligible. "We exist then, to do nothing?"—"It is to do nothing that the elect exist." And Wilde's 49

spokesman remarks that society often forgives the criminal, but never the dreamer. Not long before, Swinburne had written to the spirit of William Blake in heaven: "Come down and redeem us from virtue!"

These grand principles took their toll on the poor bewildered philistine who no longer knew what was a joke and what was— in earnest. The center of gravity had shifted outside his base. Perhaps he was dreaming, though he was surely not the dreamer. In any case, the world was being turned upside down. The chief men being listened to held their audience by inverting "truths"— systematic inversion: Ibsen, Shaw, Nietzsche, Samuel Butler had shown the way. Butler would take Tennyson's lines: " 'Tis better to have loved and lost than never to have loved at all" and recast them as: " 'Tis better to have loved and lost than never to have lost at all." Shaw said: "Do not do unto others as you would have them do unto you: you may not have the same tastes." Or again, "The reasonable man adapts himself to the world. The unreasonable man tries to adapt the world to himself. Therefore all progress depends on the unreasonable man." In his comedies, Shaw depicted the soldier as preferring chocolate to ammunition, the womanly woman as not sweet but guileful, the marriage bond as a license to sexual indulgence, the hero as proclaiming: "Two things I hate—my duty and my mother."

Before Shaw, it had been Ibsen's mission to show that the truth is murderous and ideals cloak selfishness: nothing is what anyone believes; it is the exact opposite. This thoroughgoing denial and overturn was what Nietzsche called for under the name of Transvaluation of All Values. And he, too, in damning religion, liberalism, Darwinism, and Empire, used art as the true measure of vitality. Truth is a lie in any proposition; it lives in art.

To shock by inversion is of course an old device of religions.

The Bible teems with examples of it. The high shall be low, the first shall be last, the rich will be beggars, the poor will be clad in gold raiment. Dostoevsky, whose work also comes into play in the nineties, had but followed tradition in showing the murderer as saved and the idiot as wise. But it takes an omniscient God to bring justice out of these overturns. To a godless age, the negative part of the inversion alone remains potent. The negative perpetuates itself as a habit of thought—it becomes the highest form of self-consciousness—and it destroys everything in the most direct way, not by physical means, but by corrosion at the seat of faith and action, the human mind. That is how, today, we come to find thinkers for whom dissent is a routine, sex is a rhetoric, and violence is love.

Once initiated, the addiction is not reversible, which is one reason why art ends by attacking itself. The intellectual agitation surrounding art, energized by the reflex of negation, produces a self-renewing avant-garde. Its purpose is to destroy both academic art and the art of the previous avant-garde. (The military meaning of that phrase is significant. So is the fact that the artistic meaning had not reached the dictionaries by 1886.) Thanks to these small bands of scouts fighting alone in the forefront of the whole culture, the singularity of genius is unforgotten and the appetite for change is fed. Destruction by novelty becomes an incessant function of art.

By now the ordinary citizen partakes of this benefit as well. Novelty by negation means defeating expectation and being careful to call the result unconventional, offbeat, interesting, which is with us an unfailing recommendation. Department stores find their profit in those adjectives when applied to chairs and tables that are unquestionably capable of defeating expectation. The consequence is more serious when, for instance, inversion is used to

51

titivate the classics. Since Euripides' *Trojan Women* has chief roles for women only, let us give it with an all-male cast. Even more "interesting" by virtue of greater confusion is to use an all-male cast for *Antony and Cleopatra*.

But what begins as inversion to *épater le bourgeois*—the phrase implies no more than "astonish the stuffed shirts"—soon leads to subversion. For if everything that the best-endowed people who are not artists do, think, and feel is wrong, it is virtually certain that the whole of society is wrong. Those who were of this conviction near the end of the nineteenth century took to relying on Art after abandoning society. In Germany, for example, the bestseller of the year 1889 was a book by Julius Langbehn called *Rembrandt as Educator*. Its thesis was that the ills of the Empire could be cured if the Germans took Rembrandt, an artist, as their guide, and built a new society on the three pillars of Art, Genius, and Power. Not science, not political theory, not social philosophy, but the way of art was the model, paradigm, panacea.

Where the pressure of industrialization was less acute, in Vienna, for example, or in Munich, the ideal of the intelligentsia was to fashion an "art city"; that is, to substitute the imagined for the real. Borrowing much from Paris at the hands of the critic Hermann Bahr, the young painters, sculptors, and architects grouped themselves under the significant name of "The Secession." The men of letters adopted Symbolism. Stefan Zweig, recollected long afterwards that for all of them the first glance at the morning papers was not for public affairs but for news of the theater.

This French influence is what we must now examine, for it is not too much to say that it has shaped the contemporary view of culture and society in nearly every detail. What is Symbolism and in what sense is it an agent of Abolition? You will understand, I am sure, that I do not propose to treat the Symbolist move-

ment as literature and give either an appreciation of it or a depreciation. My sole concern is cultural criticism. Symbolism, the chief tendency in what has been called Neo-Romanticism, distilled certain elements of Romantic art into highly self-conscious works that struck the first beholders as strange and difficult. These productions ushered in the period of obscure, non-objective, non-communicative art in which we still live. For the rationale we may consult the French poet Mallarmé: "I believe that there should be [in art] nothing but allusion. . . . Previous poets took an object and showed it. They deprive people with minds of the sweet joy of believing that they create. To name a thing is to destroy three-fourths of the enjoyment, . . . the bliss of guessing little by little. To suggest—that is the ideal. And it is in the accomplished use of that mystery that Symbolism consists: to evoke an object by degrees so as to show a state of mind, or conversely, to choose an object and slowly disclose the state of mind it implies by a series of decodings. . . . There must always be an enigma."

In other words, nature—the world—had lost its hold on the imagination. It had been fully exploited by four generations of great artists; and what is worse, it had been taken over by science and reduced to meaninglessness. Science had persuaded the intelligent that the universe was but the mechanical interaction of purposeless bits of matter. Thoughtful people in the nineties told themselves in all seriousness that they should no longer admire a sunset. It was nothing but the refraction of white light through dust particles in layers of air of variable density. To paint a sunset would be to compound the ignorant mistake of admiring emptiness. Common sense, the commonplace, common people were equally non-existent. The last hope for purpose and meaning was Art, which was not matter but symbol, a pure creation. So great was the power of vision in the poet or painter that Wilde's para-

53

dox, "Nature imitates Art," could be verified by looking at the world after the Post-Impressionists and Symbolists had made it live.

The devaluation of nature strengthened the conclusion reached earlier that a work of art is a world in itself, autonomous, independent of the so-called world in which we live. Art alone was in possession of Being. Painters such as The Nabis began to assert that a painting had nothing to do with what might be recognized in it. Any resemblance was accidental. The work was a painted surface, nothing more; it owed nothing to nature, objects, feelings, ideas, or expectations in the public mind. These theorists acknowledged the influence of Schopenhauer, who had shown that the world was but an illusion projected by the will, which could only be detached from actuality by being attached to art.

Estheticism, also called art for art's sake, ought clearly to be called art for life's sake. Living Art rescued man from dead nature and a putrefying society. The ideal life would consist of a succession of moments filled with the exquisite sensations that a person could contrive who was reared on art. When Walter Pater gave expression to this program, it was freed from the taint of hedonism, because *esthetic* sensations are by definition free from the grossness of the flesh. What strikes the senses in art is a symbol. What makes the symbols into a world, as Clive Bell, Roger Fry, and others pointed out, is neither contents nor purpose but "significant form." Do not ask, significant of what? You would show by the question that you do not understand art. When Whistler, in browbeating the philistines, told them that their likes and dislikes, their puzzlement or dismay were irrelevant, he felt justified in his insults because people failed to grasp the simple point that a painting is self-sufficient and art all-sufficing. Whistler's Nocturne in Blue and Silver has no connection with the Thames and

Lambeth Palace, except as they supplied a negligble stimulus to the painter's mind. It has as little importance for art as the hook on which the canvas hangs.

Since Whistler and Bell, the elimination of the world has gone farther and farther, as I need hardly say. And since the intention behind it was largely destructive, its momentum has carried destruction into art itself. Non-objective, abstract, symbolic art make for the progressive elimination of purpose and we now quite logically gaze at junk art and computer or dice art (aleatory)—products of chance. For the older genres we are compelled to use the paradoxical term "intentional art."

But it is no paradox to point out that in eliminating nature, objects, and purpose, symbolic and allusive art necessarily destroyed the ancestral connection of art with human pride and human love. The decline of portrait painting has been attributed to the competition of photography. I think it due rather to the logic of anti-denotation, the face of man being all too likely to introduce false or irrelevant suggestions into pure form. Today, when you are tempted to see human representation in art—in Picasso or Giacometti or in any example of the anti-novel—you are at once aware that the symbol is an angry distortion, a dismemberment and defamation of man, and not a reflection, much less a glorification, as it was from Phidias to the Pre-Raphaelites. Surgical remains are what we are invited to contemplate, as if the radical opposition between art and actuality were not yet clear enough.

What is clear in this progression is the artist's ever more fierce refusal to recognize a common humanity between himself and his enemy. Who the enemy is, I shall say in a moment. In the Symbolist period, Tolstoy became so outraged by this destructive animus and so obsessed by it that he wrote his famous essay *What* 55

is Art? in an effort to recall Europe to what he thought were the origins of the artistic impulse—the communication of feeling inspired by a sense of human brotherhood. He went so far in the other direction from de-natured art that he denied the name and quality of art to anything not intelligible to an illiterate peasant.

In scorning sophistication he also scorned the findings of a school of artists, contemporary with the Symbolists, but who had not given up depicting the physical world. Indeed they took the name of Naturalists to make their purpose clear. Here too the Goncourt brothers had been pioneers, and their works show—like those of J. K. Huysmans and several others—that Naturalism and Symbolism are not incompatible but complementary. Both stem from the same exasperated sensibility, which is made worse not better, by the cultivation of art. As any new art creates a new world for the beholder to embrace, it creates intolerable discomfort, it deepens disgust for the actual world. The horror is that no matter how powerful one's imagination, as long as one is sane, the ordinary world remains only partly displaced by art. That is why the novelist Villiers de Lisle Adam was driven to say—"as for living, our servants will do that for us."

The Naturalists were those artists who had withstood the blow science had dealt to *la belle nature* and who claimed the title of science for their own work of description and diagnosis. The naturalistic novel, as everybody knows, exhibits the underside of society. Its aim is to expose, to face the philistine with the horrors that his social organization creates and his complacency ignores.

This harsh curriculum of the Naturalists was effective in bringing before the public conscience the "ills of society" and destroying what was left of middle-class self-approval after eighty years of scolding and raging by Carlyle and Ruskin and Arnold. Naturalism outstripped them by the use of unrestrained sordor and

violence. It acclimated the educated ear to the vocabulary and rhythms and obscenities of the most degraded city dwellers. In Zola, Gissing, George Moore, Dreiser, Sudermann, the reader expects to be brutalized. Bruising, not catharsis, is the desired state of his soul after art has administered the proper torments. Meanwhile one instrument of the literary art—the quality of prose—has been effectively disabled. The fiction and theatre of today testify to the thoroughness of that particular piece of destruction—like the Puritan wrecking of images and stained glass in churches.

The permeation of European society by these strong emotions was aided by other agencies of the 90s that popularized the ideology of art. The theatre known as the "Grand Guignol," for example, put on quick skits of cynically atrocious brutality and bloodshed. It became fashionable, also, to frequent the haunts of criminals and prostitutes, to borrow the Apache style, to patronize night clubs such as Bruant's where the master of ceremonies hurled insults at the entering guests. Toulouse-Lautrec has recorded the setting and the actors of this masquerade.

They vanished into limbo, but the tone remained. The Comic Spirit has always abused the world with ridicule and invective, but not until the flowering of our modern art did uncontrolled rage in vituperation and (it must be said) in spluttering sophomoric insult too, find their way into works of artistic pretensions, which in time became models and precedents. In this vein the French hold a monopoly of invention. They were the first thoroughgoing Abolitionists. I think, for example, of Lautréamont's *Poésies*, Laurent Tailhade's *Au Pays du Mufle*, and Jarry's *Ubu Roi*. The last-named is highly regarded as a satirical play, but its angry dullness only matches its object, which was a school usher whom the author hated as a youth: small game for so much venom, pitiable faults for a poet to castigate. The sophomoric strain was

57

to have a great future. Novels, poems, prefaces, critical essays, drawings and paintings, as well as plays, continue to be marked by the same impotent hate, the hate that Jarry felt when he announced: "We will not have brought down everything in ruins until we also destroy the ruins." This is the artist planning to be Samson in the temple with the Philistines.

Such, then, are the two streams of lethal influence: idealist and naturalist; or, to pair them in another way, sanctuary art and revolutionary art. Do not be tempted to use the derogatory term "escapist" to characterize the genre I have called sanctuary. Escape is difficult; symbolist art did not make it easy. And when escape is from a disaster, it is at once necessary and wise. Nor should you call Naturalism utopian in its discontent. It is meant to nauseate us and it succeeds. Both types of art regard the real world as disastrous, both are intended to make us emigrate, leaving it to its own perdition.

This anger is the same that we see informing the ubiquitous anarchism and dissidence of our day. The great grievance against the world now felt by many, almost without thought, is the grievance of the artist; or to put it more exactly, whatever the source and substance of the contemporary grievance, of the outraged protest, it regularly assumes the forms that artists have made canonical for the last hundred years. One good reason why this is true is that our world is socially and politically the same world. It is liberal, democratic, capitalist, and individualist. In the cant words of the time, it is a bourgeois world, dominated by bourgeois values. What a convenient word is bourgeois! How expressive and well-shaped for the mouth to utter scorn. And how flexible in its application—it is another wonderful French invention!

Now I am as sick and tired of "the bourgeois" as anybody in
the western world, but for other reasons than the usual, and I

must state at some length why they differ, if we are ever to know what it is that the ideology of modern art wants to destroy. I begin with a question of identity. What is this *rising bourgeoisie*, which is automatically invoked to explain everything—the success of the national monarchies in 1500, the success of the French revolution in 1789, the triumph of capitalism and machine industry in England, the passage of the Reform Bill of 1832—why is the bourgeoisie always rising and never risen? Bourgeois means townsman. So the bourgeoisie starts to rise well before the twelfth century, when the great towns of Europe and their guilds were flourishing. It rises again in Italy in the fourteenth century to spur its prosperity and the fine arts of the Renaissance. And when we say Italy and bourgeois we are blurring some realities. There was no Italy—only towns. The bourgeois of Florence ruled by the bourgeois Medici were artisans and bankers; those of Genoa and Venice were merchants and sailors. So were the bourgeois who supported the confiscations of Henry VIII in England and backed up the piracy of Queen Elizabeth against Spain, in hopes of buying estates and ceasing to be bourgeois.

Across the Channel, the bourgeois in Holland achieve maritime power and civil liberties and "produce" Rubens and Rembrandt. Then the bourgeois in England fight a civil war against the Cavaliers, but the capitalist bourgeois of London do not favor this rebellion at all. Meanwhile the French bourgeoisie has been buying royal offices under the Bourbons, and with or without a noble *de* constitute the efficient bureaucracy of Louis XIV—which is why, I suppose, they make a first revolution against themselves in 1789 and two more in 1830 and 1848. Similar upheavals occur in Germany, Italy, and elsewhere. The only place unprovided with bourgeois is Russia, which accounts for the Marxist revolution beginning there, Marx having toiled all his life to bring about

59

a revolution of the proletariat against an entrenched bourgeoisie.

You perceive why I will not have the bourgeois on any terms. He is not a reliable historical character. He is shifty as to chronology, status, income, opinion, and activity. So much for the historical bourgeois. Is there perhaps an intrinsic bourgeois whom we would recognize as now universal and who can bear the burdens of 150 years' abuse? Gautier, you remember, reviled the bourgeois for his over-developed sense of utility which excluded art, since art—according to all esthetes—is quite useless. Flaubert defined the bourgeois as a being whose every mode of thinking and feeling is low. The French, you see, have devoted a good deal of attention to the animal, and "filthy bourgeois" had become a regular French epithet by the time Cézanne visited his friend Zola and applied it to him when he found the novelist in a well-furnished flat with thick carpets.

But all these judgments lack precision, like the historical references to the rising bourgeoisie. We find a description, fortunately, in the French historian Taine—himself a thorough bourgeois. Taine attributes the birth of its bourgeois character to the "well-administered monarchies of modern times." He means the state bureaucracies. "Of all the types of men shaped by society," says Taine, "the least capable of arousing sympathy is the bourgeois. His condition deprives him of all great ideas and great passions, at least in France, where the bourgeois has thrived better than anywhere else. The government has relieved him of political responsibilities and the clergy of religious. The capital city has monopolized intellect as the court did fashion. The efficient administration of public affairs spares him the worries of material need and the anxieties of risk. And so he lives, dwarfed down to scale with the humdrum, . . . empty of curiosity and desire, in-

60

capable of invention and enterprise, limited to a modest profit or income. He nurses his savings, seeks vapid entertainment, picks up discarded ideas and cheap furniture, and his whole ambition is to rise from Grand Rapids mahogany to department-store Swedish. His house is the reflection of his mind and his life in their incoherence, pettiness, and pretension."

Are we better off after this definition of a social type who is petty, timid, and safe? If as Taine says the government has relieved the bourgeois of public responsibilities, why is the bourgeoisie called the present ruling class? Who runs the bureaucracies —not the nobility, surely, or the proletariat? And if this fellow without ideas and passions lacks enterprise and hates risk, what class name do we give the large-scale entrepreneurs and industrialists, with their grand passion for money, for trusts and cartels and colonial ventures? It could be just as plausibly argued that the chief vice of the bourgeois is restless self-aggrandizement at the cost of incredible risks. From the twelfth to the sixteenth century the burghers were men of daring who fought the predatory nobles to a standstill; as we see from the remains of their fortified walls. And since then they have polluted the globe with their enterprising power.

As for the aristocracy commonly contrasted with the bourgeois, it too is an uncertain fiction. Nobles have often been former bourgeois who had bought land or offices carrying titles of nobility. Intermarriage between wealth and birth is a perennial phenomenon. And in reverse, it is documented fact that many of the nobility everywhere have for centuries engaged in trade. Aristocratic families that still have money necessarily did so, since land is a poor provider. They began trading as soon as it was profitable, and the peculiar blight that overtook Spain in the sixteenth cen-

61

tury was but the result of an anti-bourgeois cultural fashion: everybody wanted to wear a sword and act like a hero of romance, too proud to either trade or work.

The bourgeois trader of Barcelona or London in those days was of course quite different from Ruskin's *bête noire*, the manufacturer of Manchester or Birmingham who ruins river and countryside with his "works." He, in turn, differs from the bourgeois who led the nineteenth and twentieth-century revolutions—students, professors, intellectuals such as Marx and Lenin, who cannot be accused of lacking ideas and passions. One last point to complete the muddle: the overwhelming majority of all anti-bourgeois artists are and have been bourgeois born and bred.

In short, the interplay of class, historical time and place, and individual character is too complex for offhand labeling. To call out "bourgeois" and visualize a type is to be both ignorant and unimaginative. Taine, a bourgeois from the professional class, depicted a petty bourgeois tradesman of peculiarly low grade, and himself consorted with *grands bourgeois* who ran the government and economy of France and also with ex-bourgeois bohemians who created its works of art. If social condition shapes character, it is an act bordering on idiocy to call these four groups by the same name and expect from them identical behavior.

It would be hard not to see in the artists' persistent naming of *the* bourgeois as the enemy a hankering after a bygone social stratification that was supposed to bring together "the great" in art and in society. From Balzac and Hazlitt onward, the genius has repeatedly been thought of as the true aristocrat. But there is a snag in the scheme. Elie Faure gives us a clue to it in prefacing the modern volume of his *History of Art*: "There is in a democracy only one aristocrat, the artist. That is why he is hated. That is why democracies idolize the slave that belongs to them body

62

and soul, the one who has forgotten his noble task, given up love and gone in for producing the easy art which suits the cultivated classes. . . . Even when he is famous, hated, and manhandled by the mobs of the salons, by the art lovers and the critics, even when he forces his way into the Academy or the great schools, the artist is alone." After which Faure gives in the same passionate tone a page of examples of modern artists misknown and mistreated. All these contradictory claims help settle the point at issue. It is obviously not Taine's petty bourgeois who is to blame for the artist's difficulties. Nor—it seems—does the upper bourgeois society—the cultivated classes—satisfy any better the artist's advocate, Elie Faure.

Should we then rephrase the grievance and say that the enemy of art is not any one of the fifty types of bourgeois, but rather the so-called "bourgeois values," which control action independently of character? Facing the unsatisfactory present, it is not hard to sentimentalize about a past in which aristocrats and princes all had excellent taste, or a universal church that knew how to employ great talents, or—best of golden ages—ancient Athens, which was wholly a people of artists. None of these additional fictions will stand up to scrutiny. No system of patronage has ever given satisfaction. Historically the artist has been a slave, an unregarded wage earner, a courtier, clown, and sycophant, a domestic, finally an unknown citizen trying to arrest the attention of a huge anonymous public and compel it to learn his name.

There is the rub. It is not from textbooks of political theory that the artist learns to decry the vices of the bourgeoisie; it is from contact with the stolid playgoer, the greedy middleman, the wayward patron. These are the living obstacles barring the way to fame. To achieve even a modest success in the arts is endlessly difficult. It has always been so and more than ever in a democracy 63

it is idle to imagine a frictionless device for recognizing merit the instant it appears. There is no way to *organize* the relation between an artist and those he addresses. To make him a government employee, as some artists periodically propose, would be perhaps the worst conceivable relation, even if the scheme did not automatically favor the time-servers. In almost every relationship with his fellowmen the artist will encounter a preponderance of shallowness, conceit, envy, jealousy, profit-seeking, treachery, and dumb resistance. He is not the only man to find others opposed to his will, but the opposition he meets is in proportion to his great demands, and it seems eternal. His own share of the same weaknesses worsens the case. He overlooks them magnanimously, being conscious that he is working in the realm of the unique and is trying to *give* something, not take to fill his pocket. Hence the artist's ineradicable sense of wrong.

We might conclude that the artist's vow to exterminate the bourgeois stems from the fact that nobody else is around to serve as scapegoat for the vicissitudes of Art: the aristocracy is gone. But many artists hate the masses too, in the same abstract way of scorn for their tastes and their appetites; only, the tastes of the working class so far do not affect the prosperity of art. The material appetites of the whole society do. The clue to the conflict is in this question of business. The artist wants to give and (in modest measure) take for his needs. The rest of the world buys and sells. The contrast makes clear the vague affinity of art with aristocracy and the hatred of both against the bourgeois. The nobleman has courage, spends without counting, despises petty detail. There is a great air of freedom and unselfishness about the nobleman. He will throw his life away for a cause, not calculate the returns. That is the noble *ideal*. In reality, he lives by the serf-

64

dom of others and he broadens his acres by killing and taking other people's land—"the good old rule, the simple plan, That they should take who have the power, And they should keep who can."

The bourgeoisie opposed such noble free-handedness and supported a king who would replace "the good old rule" by one less damaging to trade and manufacture—and to the peasants' crops. But the regrettable truth is that there is no glamour about trade. Trade requires regularity, security, efficiency, an exact quid pro quo, and an exasperating attention to detail. You may read in a large book by the economic historian Werner Sombart how slowly Europe taught itself this new behavior called for by the use of money and the expansion of trade. There is nothing spontaneous, generous, or large-minded about it. Man's native love of drama rebels against a scheme of life so plodding and resents the reward of qualities so niggling. This is a generality: all trading nations and classes have throughout history been looked down on, all the more because trade on a large scale has a natural tendency toward lying and fraud.

The hateful character of trade explains the paradox of so many bourgeois artists and intellectuals denouncing the bourgeoisie. They are saying: "Don't class us with people in trade, with business men." But the taint goes deeper than they think. "Bourgeois values" take in much more than the commercial, as D. H. Lawrence darkly hints when he says in the poem "Red Herring":

> My mother was a superior soul,
> A superior soul was she,
> Cut out to play a superior role
> In the god-damn bourgeoisie.

65

Lawrence has in mind certain manners and pretensions; but even that is not the end. Bourgeois values are no longer the apanage of any class: they are by now the sum total of inherited European ways. Some come from the aristocracy, for instance, the code of courtesy; others from the artisan class, such as the respect for work and workmanship. Many are ancillary to trade, their origin forgotten or taken for granted as if they were products of nature; for example, the preference for social peace, the habit of paying instead of robbing, the desire for exchanges with other peoples which produces civilization, the taste for variety, the habit of invention and inquiry, and most characteristic, the conscientious love of art itself.

It is moreover a fact that scientific method (including the devising of algebra, which began as a business ploy), the notion of orderly government and of accountability by officeholders, and generally the effort to substitute reason and reciprocity for arbitrary will—all these are "bourgeois values" just as much as the vices of trade, though one can understand that for sophisticated minds the merits have no imaginative weight compared with the ugly spectacle of money-making. Few artists would deliberately choose the "aristocratic values" and say with Froissart that "to rob and pill" is the good life; nor would they relish being serfs. When the contemporary abolitionist gives as a reason for destroying the bourgeois world its "materialism," hypocrisy, lack of justice and oppressive arrangements, he is in fact giving reason for destroying every civilized society that has ever existed. The notion that materialism is a characteristic of our time alone is fantasy. The Greeks, that supposed people of artists, were traders and imperialists, who built the Acropolis for ostentation and with money stolen from their allies. In groups and individuals the love

66 of money has been denounced since Biblical times, and it brought

about the downfall of the mendicant orders dedicated to holy poverty.

Especially apropos of art it is tiresome to hear materialism talked of as a modern sin that we could get rid of if we went to museums more often. The average man, middling and sensual, is here to stay. Human stupidity is ancestral and endemic. The ship of fools has sailed in every age from every port. Finally, the aggressiveness and hypocrisy we find as we look about are part and parcel of a relatively free social existence. Individuality survives thanks to the balance between them. Their ugly side appears when we do not like their form or result. Otherwise we call the one civility, respect for others, self-respect, the right to privacy, human dignity; and the other we call spirit of enterprise, innovation, leadership, originality: who more aggressive than the artist when he shatters our habits of eye and ear as a means to violate our minds?

These being the conditions of social life in large groups, the limitations of mankind in the mass, it follows that to represent them as a collective infamy deserving opprobrium and death is at bottom the wish to destroy mankind as it is and desire in its place a wholly *unconditioned* life. This conclusion is confirmed when we scrutinize the hopes of revolutionary artists outside totalitarian countries. They do not seek the tighter regimentation they would get under dictatorship or the closer contact with the dullness of humanity. They imagine on the contrary the anarchist heaven of free spirits moving through life in easy, frictionless self-development, because no longer bound by material needs or vulgar ambition. It is, once more, an unconditioned world.

The point I have been making about classes and societies should not be misunderstood as a defence of the bourgeoisie or as an irrelevance to the verities of art. No civilization is defensible from

the point of view of the ideal, and from the point of view of history none needs defence, because ideals do not occur in experience: they are variable standards imposed by the mind. These limits become relevant to the uses of art when we see art and artists advocating not merely revolution—art has no monopoly there—but dissolution of the entire frame of things, on the ground that it is precisely not the ideal—not art. The visionary has the right to prefer annihilation for himself, but has he the right to seduce others into it by converting the arts to that sole end?

After 150 years of repetitious denunciation and increasing anger, what can be credited to the effort? Patronage is still chaotic and unlikely to improve. The philistine, aware of his unworthiness, has virtually disappeared—or at least been silenced. Indeed, he has begun to envy the artist—not the artist's technical prowess or his fame, so much as his power, mysteriously associated with his emancipated life. Yet no sooner was the philistine moralized than he had to be demoralized, made permanently despondent about his condition. In turning Abolitionist, art attacked the members of society most ready to support the artistic outlook—in short, destroyed its best audience. What is more, in persuading the bourgeois to seek an elemental relation to life like that of art, the artists defeated their own purpose. The more they made the work of art anti-world and autonomous and the more they obliterated resemblances with daily life, the less the chance that esthetic experience would shape practical minds capable of reshaping society.

Should there be any doubt that these mistakes were the work of artists, and not of their clumsy interpreters, I may cite two telling incidents from the novelists. Proust shows us his narrator, disenchanted with love, friendship, conversation, and society, able to survive only through literary creation. This is the very opposite of the role that Schiller assigned to the genius, that of spon-

taneously using a great natural power to express a poetic vision. Proust's creator is a castoff, a reject. Again, Thomas Mann shows us an engineer who acquires self-consciousness—sophistication—in the usual way, and who consequently cannot possibly go back to engineering in Hamburg. The only thing he can do is write a novel. Art, art, art! The success of the ideology of art ends in self-stultification. For it is one thing to give mankind an inkling of art's ideal world; it is another to turn the whole population into professional artists.

In yet another way the genius theory came to a bad end. The greatness of the artist as a culture hero was not matched by his greatness as a social being. If we except Wagner, who in the nineties was the idol of poets and painters as well as musicians, precisely because he had gained a kingly eminence, the artists of the time shared a worse than meager lot. Unlike most of their predecessors, they did not conquer society after a long or short period of youthful alienation. They remained bohemian to the end. Bohemian originally means gipsy, that is to say, wild, outcast, hunted, and wretched. Estheticism was the time when poets came to be called accursed. Yeats, who escaped the blight, observed with horror how many of his contemporaries were drunkards, drug addicts, criminals, suicides, and madmen. The genius as natural man, healthy and whole, gave way to the artist who must be maimed, not to say degraded. It is from his wound, his unfitness, that he draws his power. The contradiction between his vision and his state parallels the conflict between art and the world.

Looking back over the last 80 years, one is entitled to speculate that our day could have escaped this bitter cultural suicide. The extreme self-consciousness of the nineties recognized itself as overwrought, called itself decadent and ascribed its dangerous ripeness to the *fin de siècle*. But soon a new surge of vigor and inven-

69

tion showed itself in the men who came of age around 1905. Between that time and the outbreak of war in 1914 they made things new in the arts; and no longer by echo and allusion but by taking fresh starting points. Cubism, Constructivism, Expressionism, Futurism, the new architecture, and the consciousness of Time-Space led to original productions and gave models for future use. Such vitality as our century can show springs from that decade.

But the closing date 1914 warns us of what was to overtake the new start. The four years' war ended the European Age as the revolutions of 1848 had ended the Romantic revival. The earlier war split the peoples horizontally, denying their domestic unity, as the later one split Europe diagonally and denied its cultural unity. Between 1914 and 1920 untold numbers of gifted artists and thinkers perished or lost their will to create. The survivors who flocked to the Communist Party were seeking a cause with which to reanimate that will and restore a believable function to art. This plausible step was the beginning of a great confusion. The revolutionary artist, formerly a lone fighter with a self-made program, now obeyed a doctrine, and kept his eye on his followers and masters as well as his distant Mecca. The stuff and style of revolutionary art could no longer be advanced and difficult, but must suit the mind and conditions of the masses. All the totalitarian regimes declared modern art decadent and drove it from the public scene.

Other extraneous causes aggravated the confusion of styles. The postwar generation had not been in touch in the usual way with the men who had reshaped the arts before 1914. Even the formal education of these younger men had been scamped during four years of war. To them, the whole period from 1870 to 1914 was

70

modern art indiscriminately. And so it has remained ever since. Baudelaire who died in 1867 still seems a recently canonized master, together with Rimbaud, Cézanne, Van Gogh, Laforgue, Debussy, and the rest. All stand on the same plane of nearness as Stravinsky, Kokoschka, Yeats, Proust, or Picasso. After 1920 Dadaism, Surrealism, and German Expressionism recast or scrambled prewar Futurism, Simultanism, and Cubism, infusing them with still older elements drawn from Symbolism and Naturalism. To cite but one instance: T. S. Eliot, who emerged at the close of the war, was schooled by Ezra Pound, a typical figure of the prewar years, but is emotionally and technically a direct heir of Jules Laforgue, who wrote and died in the eighties. To be "modern" in 1920 meant nothing distinctive, stylistically or emotionally. Lytton Strachey was still killing off the Victorians who had been slain by Shaw and Wells and Wilde thirty years earlier. Freud and Einstein were just reaching the great public with their ideas, which had been new in 1905.

Since 1920 the cake-walk progression, two steps forward and three back, has continued, regulated by the advent of successive groups of newcomers to the world of art—the American expatriates who rediscovered Europe in 1925 or the beneficiaries of expanding democracy and education, of travel and the mixing of peoples by further war. The new generations, moreover, are unlike any past ones in being emancipated from earlier academic, and social prejudices about art. Every five years during the past half-century has seen some fresh layer of the population brought into the current of the arts, the current that now flows through colleges and even secondary schools as it flows through the mass media, politics, and the business world. This wide irrigation explains why the period since 1920 has been one of return and repe-

tition, of small variation and large multiplication. Art and sociali-zation by expanding at the same time made cultural plagiarism unavoidable.

Confusion such as this is naturally destructive of much that in a clearer atmosphere would shine for our rejoicing. But do not despair at all that I have had to set forth as the handiwork of Art the exterminator. It is only one side. The invigorating power of art is also a fact, despite art's pretension to pre-enacting the Day of Judgment. The question I shall deal with next time is whether that invigorating, life-enhancing power is in truth a means of salvation.

Art the Redeemer

A week ago I singled out and described a number of ways in
which, for 150 years, art has served the purposes of destruction.
By the tradition of the New, art unremittingly destroys past art,
though by the cognate tradition of historical sympathy we deny
ourselves the unity of a contemporary style. By making extreme
moral and esthetic demands in the harsh way of shock and insult,
art unsettles the self and destroys confidence and spontaneity in
individual conduct. By undermining the ancient presumption that
state and society are justified, art impairs their effectiveness and
thus proves its own case. By associating the respect for art de-
veloped during the last half-century with the dominance of "bour-
geois values," art ends by destroying art itself. In sum, the present
conditions of civilized life and the character of men in the mass
are not good enough for art to tolerate. Its effulgence pours death-
rays on a substandard world.

Since such an onslaught can go forward only to the point where
it succeeds in achieving that total "ruin and destruction of ruins"
announced by Jarry, we must now look into the parallel claim
that art—the life of art—redeems man from these very conditions
and limitations and bestows on him the blessed estate that earth 73

denies. Today being Easter, the subject seems doubly appropriate. What art promises is the modern equivalent of the program contained in John Hayward's seventeenth-century best-seller, *Hell's Flames Avoided, Heaven's Felicities Enjoyed*.

As to the felicities that art can confer, I imagine there is no disagreement. Anyone who early in adult life finds himself capable of responding to El Greco's *View of Toledo* or Rubens's Marie de' Medici sequence, or Delacroix's *Crusaders in Jerusalem*; anyone for whom, in retrospect, *Don Giovanni*, the *St. John Passion*, or *The Damnation of Faust* serve as points of reference in his soul's history; or again, anyone whose life of playgoing and reading is marked by enduring liaisons with *Macbeth* or *Tartufe*, *The Prelude* or *L'Education Sentimentale* will testify from first-hand knowledge that great art has the power of transfiguring the aspect of the world, while also mysteriously recasting in new shapes the substance of the self.

It is enough to gaze at the west front of Chartres cathedral or to be seeing Shan Kar the Elder do his Sword Dance to know that something unique and unaccountable is acting formatively and beneficially on something within. The experience of great art disturbs one like a deep anxiety for another, like a near-escape from death, like a long anesthesia for surgery: it is a massive blow from which one recovers slowly and which leaves one changed in ways that only gradually come to light. While it is going on, the reported physical signs of such a magnificent ordeal have been reported to include sweating, trembling, shivering, a feeling of being penetrated and pervaded and mastered by some irresistible force. Being *thrilled* (that is, "drilled") would be the proper phrase if it had not been degraded by misuse.

All these signs and similes suffice to show that the deep shock of apprehending a great work of art is no affectation. Something

74

takes place and it is tremendous. Common agreement about this species of voluptuous stress, which differs in its source from others equally disturbing and sought for, has led to isolating and cherishing what is now known as the artistic experience. Many studies seek to explain it, which is not the purpose here. We want rather to learn what follows the upheaval. By general consent, art gives the beholder a sense of active well-being and the impression of possessing new knowledge. Its source, (he feels) the work of art, has universal validity and sway. The subject of that knowledge—which is not mere information—has no precise limits. After undergoing a masterpiece, we believe we know more about ourselves and others, about this world or the next. By the next world I mean any ideal or abstract realm you choose. The fact is, as regards any worlds or creatures, all art is "realistic"; I mean that it testifies to another's perceived reality. Art does so by its very intention. No artist goes to work saying to himself: "What I am doing is to give a false account, a picture of the non-existent, just to fool the people." Every artist on the contrary professes [I am quoting E. M. Forster] to "create a world more real and solid than daily existence . . . , [a world] eternal and indestructible."

The only question is: which world or worlds are being represented, symbolized, or enlarged by a particular work. And since the great works impress so transcendent a reality on the mind by ordinary material means—words, sounds, colors, and lines—art seems to give proof of a fundamental connection between man's life and the Infinite. In Baudelaire's poem, *La Rançon*, he says that man has two fields, rich in deep loam, with which he can pay his ransom; they are Art and Love. Music, says an English poet and musician, is "the imagination of love in sound. It is what man imagines of his life, and his life is love." The association of love with art is traditional among poets, and it is sustained by the

75

similarity of the effects of each on the personality—raptures and transports attend both. Love also gives intimations of the infinite and is said to conquer death. All these links bring us to the last and oldest pair in the series of analogies, that which equates with love the Reality of Realities called God.

This whole train of thought is taken for granted by those who have been reared on the art and criticism of the nineteenth century, whether or not they think of themselves as religious. They may believe with Cardinal Newman that "poetry is the refuge of those who have not the Catholic Church to flee to and repose upon." Or they may invert the terms like Santayana, and say that "Religion and poetry are identical in essence and differ only in their practical links with daily life." Or again, they may find with T. S. Eliot that the beginnings of the whole emotional sequence often lie in the primal energy of Eros: "For the boy whose childhood has been empty of beauty, the boy who has never learned the *detached* curiosity for beauty, the sexual instinct when it is aroused may mean the only possible escape from a prosaic world. Hence a danger which may be followed by a still greater disaster, the passage from a period of violent excitement into a maturity of commonplace. We must learn to love always, to exercise those disinterested passions of the spirit which are inexhaustible and permanently satisfying."

We see in this probably confessional passage of Eliot's how the reality seen through art is equivalent to that which religion formerly brought within the reach of man. Both redeem man from selfishness and the commonplace. Both ensure a passionate excitement that is spiritual and therefore permanent. Nor is this all. For some devotees art redeems not only from inner baseness but also from outer constraint. In a remarkable lecture delivered in 1852, Henry James, Sr. defines Art as "all those products which

do not confess the parentage either of necessity or duty." And he draws the contrast between this freedom and daily life: "When I go to pay my house-rent, I leave my human love at home with my wife and children and come into purely inhuman relation with my payee. I hurry into his presence and hurry out, careless of the thousand noble qualities which may glow in his bosom, or animate his voice, because all these things are overlaid and defaced by the spurious and unequal relations established between us. Everyone would be greatly happier if being brought into the world without his own consent, he might be permitted to live in it without the continual consent of somebody else."

We recognize here the yearning for an unconditioned world, the very world of which art became the realization when it replaced traditional religion. Art has the same essential features, implied in the cliché we met earlier, that each work is a "universe that only answers to its own laws, supports itself, internally coheres, has a new standard of truth." One might ask whether these statements about a work of art are themselves true, or whether they have come to be superstitiously accepted because they express permanent desires which failing religions left floating and to which the cult of art gave a new home. Consider, for instance, this intimate reminiscence which the French novelist Romain Rolland made public in the preface he wrote in 1927 to the nineteenth printing of his *Life of Beethoven*, a work that sold well over 100,000 copies in French alone. He looks back to the year 1902 and says: "In Mainz I heard a festival of his symphonies [Beethoven's], conducted by Weingartner. Alone with the creator, confessing myself to him on the foggy banks of the Rhine . . . , full of his sorrows, his courage, his passions and his joys, kneeling but lifted up by his strong hand, which baptised my first-born—the child *Jean-Christophe* [a long novel by Rolland]—I went back

77

to Paris with his benediction, restored, having taken a new lease on life and singing a hymn of thanks as from a convalescent to the Deity. That hymn is the present book."

There could be no clearer parallel—not to say parody—of confession, penance, and absolution. But we are not concerned at the moment with its truth or illusion. The point is rather to observe the influence of these emotions on modern art itself, the shaping of it so as to enhance its power to uplift and redeem.

Clearly, art is expected to embody unity and typify the absolute. These are the signs of transcendence in traditional religions, and the corresponding demand on art has been that its works be perfect in design, structurally strong, and less and less concerned with the actual world. "A poem should not mean, but be," wrote Archibald MacLeish, and the manifesto in this convenient capsule form was universally re-echoed. In keeping with it, a canon of criticism that dominated the scene for decades asserted that nothing extraneous to the work should be brought in to judge it or facilitate its understanding. The practitioners of the method refused to acknowledge that their commentaries introduced ideas or information not already in the poem—quite as if their glosses on the changed meaning of words, on etymologies and comparisons of evocative power were not just as "extraneous" as the mental make-up of any particular critic.

We can feel in this rage for autonomy and purity—not limited to the devotees of one art more than another—how intolerant they are of reminders that the world is miscellaneous. This attitude marks an important difference between art and religion, for in the old scheme of salvation one had to endure the chaotic present to earn the peaceful hereafter. In art, if the work is sufficiently pure—and oneself too—one can obtain instant surcease; one can feel "ransomed"—to use Baudelaire's imagery—from the prison

78

made by what he called "the four walls of the Real." Actually, the image does the poet a disservice: the walls are not real—provided faith is strong enough. Transcendental religions and philosophies have always taught that earthly life is only a shadow, reality lies beyond. This dogma governing the use of the arts for many people to this day is but an unconscious Platonism, not to say an unorthodox Hegelianism.

But one is entitled to particulars: what exactly does the experience of art redeem from? The seven deadly sins appear to be: Utility (also called Materialism), Inhumanity, Anonymity, Relativity, Mediocrity, Confusion, and Reason. Some of these overlap or intertwine. For instance, men use Reason to pursue the Useful, which in turn serves their Material needs. Utility, as we know from Gautier's having told us 140 years ago, lowers the gaze of men to ignoble things. Art is noble through being useless; that is, useless for keeping the body alive, which always involves struggle over matter. Art is strictly immaterial; not what it physically shows on canvas or in print but what lies behind for the perceptive *is* the art. Again, in a work of art, everything is set forever; form is indestructible. No shifting relative judgments about it are possible. Secure from uncertainty, the beholder finds harmony in his soul in place of the confusion of daily life. Were it not for its incurable mediocrity, mankind could overcome its materialism and inhumanity and be united through art in a common brotherhood of worship.

Under bourgeois liberal democracy the urge to be redeemed can also take the form of wanting to stand out from the mass. "Hell is other people" as a contemporary sage informs us. Before him, Ibsen, Strindberg, Nietzsche, Ortega, T. S. Eliot used art as a touchstone in this predicament of lonely superiority. "Artist natures," when they are lucky, find one another instead of being

79

separately lost and angry amid the horde of the insensitive and the self-seeking. Self-selection through the love of art is not altogether a voluntary act. It partakes of the action of a magnetic field on a suitable particle. It is not the work of reason, laborious and abstract, but the work of the esthetic faculty—Imagination—which fuses all the other powers of man, misused in common life.

No wonder that the life of art so conceived elicits the ultimate superlatives. Each school, critic, lover uses the language of ecstasy to name his experience of the highest and noblest power. As the religious speak of the Lord of Hosts, the all-Highest, the Supreme Being, so the artistic defer in hyperboles to the great magicians, the masters of reality, who overpower them with art. And reflecting that this power alone is exerted without ulterior motive, the devotees compare their own sudden release from aggression to the heaven talked of in every lofty mythology. They are remade and redeemed.

At the same time, advanced civilizations are bound to suffer from their long memory, their piling up of artifacts and ideas—the dreadful clutter that Balzac depicted in the curiosity shop of his *Peau de chagrin*. The cure for this is generally some form of Primitivism. For as Freud pointed out, the sense of stifling in civilized life comes from the "progressive rejection of instinctive ends and a reduction of instinctive reactions." Art, by attacking conventions, releases unconscious impulse and restores the spontaneity of youth. Already in the late eighteenth century, as you will remember, Schiller had summoned the genius to do this for us, to bestow a new virginity on the modern soul. And Goethe a little later, observing the load of self-consciousness carried by his contemporaries, shuddered at the thought of future ages, for whom the burden could only increase. With us, not merely the love of art, but of primitive art, serves as a palliative. We enter if

80

not into simpler emotions, at least into simpler renderings that are also fresh. "What is needed of art," said T. S. Eliot, "is a simplification of life into something rich and strange."

This need to recover directness and thoughtlessness also inspires among us an obsessive contriving of experiences of pure sensation. A great deal of contemporary art finds its justification in this effort to short circuit the beholder's reason and rejuvenate him in a bath of sensation. Large canvases all in vibrating shades of red evoke no memories, ideas, or feelings, but irradiate the soul through the eye and re-constitute, retemper the distraught spirit. At other times, the stimulus is even less highly organized. One color; just a few lines; sound for the sole pleasure of hearing = minimal art. In a recent memorial tribute to the late Stefan Wolpe, the distinguished American composer Elliott Carter told how in an advanced composition class some years ago, Wolpe had suddenly abandoned the syllabus and sat at the piano playing every interval from the minor second to the augmented ninth, soft and loud, singing, shouting, and talking in a strain of primitive wonder about these miraculous vibrations.

That they may have religious significance is clear from another anecdote recently told me about a gifted and highly trained young painter of deep mystical feelings. After striving in several directions, he found that all he could do to communicate his vision was to cover a square of canvas with an even layer of pale yellow. When he was despondent, he would use charcoal on white paper for the same totality of effect. In the end, baffled by the difficulty, he joined a religious order.

In that instance art failed to perform its redemptory role; but the case also suggests that from Surrealism and its automatic writing to the various forms of Aleatory art, the same desire is present to abdicate and simplify and regain a child-like immersion in the

81

totality of Being. For the artist, the freedom that chance gives is from the esthetic effort itself, complicated as it is for him today by the crippling awareness of past art. For the spectator, the corresponding virtue of—let us say—an action-painting produced by throwing or dripping paint is the release from analysis, from the need to discover meaning and intention. One has but to yield to the mystery of color or sound or uncoordinated words in order to be free.

In the relentless presentation of physical sexuality, a similar motive is at work. It compounds the overthrow of convention with the surrender of self-consciousness. Again, in the kind of fiction that is said to be written in the same manner as musicians improvise, it is noteworthy how much space goes to drunken reverie and incoherent conversation. The result may not prove encouraging to the reader's own spontaneity, but it argues a general need for mental regeneration. A more direct method is drug-taking, but so far it has not yet repeated the literary successes of Coleridge and De Quincey. "Expanding the consciousness" in the interests of art and the inner life must be carefully distinguished from merely thinning it out by common narcosis.

The next and last promise of redemption differs totally from the preceding. It is that offered by revolutionary art, in the sense of art dedicated to bringing about political revolution. Calling a *style* or technique of art revolutionary by itself signifies only that it appears new and opposed to former styles. *Political*-revolutionary art is a logical and practical application of the discovery that art has the power to foment hatred of the world we live in. This power acts in two ways—by creating disgust through depicting what is and by creating hope through depicting a better life. Revolutionary salvation from the present may even be promoted by showing the actual as so abominable that any other state is to be

preferred. This indirect path is the one by which most contemporary art reinforces revolutionary art regardless of its own intention. *The Waste Land* is as tendentious as the murals of Diego Rivera.

The political use of art began with the French Revolution of 1789. The patriotic totalitarian mood inspired plays, songs, canvases, dances, and fictions composed to show that the ideals of liberty, equality, and fraternity were the only tenable ones. Priests and kings were the villains of every piece, men of evil being indispensable to propaganda. Revolutionary art must follow the pattern of melodrama if it is to make its big positive points and be understood at a glance by the masses. But fine artists can also believe in art as in effect revolutionary without themselves producing propaganda of this crude sort. They simply see art as purging society of its sins, perpetually redeeming and remaking the world. In the despondent aftermath of the First World War many European painters, writers, and musicians joined the Communist Party with this purpose vivid in their minds, but without materially changing the aspect or direction of their work. The underlying hope of heroic service and self-justification was enough. Thus an English novelist of the early 1920s brought together in a story a scientist and an artist violently at odds, and made the artist shout: "Idiot! Do you not understand that only through cleansing torrents and cathartic hurricanes of art can the world ever again become a place—decent or otherwise—to live in?"

Much earlier, Tolstoy had denounced in a famous essay all the coterie art of his own time and proclaimed that estheticism was not properly art but only an elegant pastime. The test of true art was its being intelligible to the least instructed peasant, and its power thereby to bring all men together in one brotherhood of mutual pity and love. William Morris, as a socialist, agreed with

83

Tolstoy though sharing only half his political views, the half directed against the ruling class. Morris despised the avant-garde, who "communicated only with one another as though they were the possessors of some sacred mystery." Their works were "ingenious toys for the rich only," and he predicted that art would destroy itself "because it is not as accommodating as the justice or religion of society." The belief that social justice and religion are the soil of worthy art goes back (as we know) beyond the 90s to the Romantic period, when the unity of culture first appeared as a great truth.

Such critiques as Tolstoy's and Morris's maintain that individual salvation through art is not enough; it is selfish and cowardly; the whole state must be redeemed by the forceful interaction of art and society. Art then becomes the measure of social grace. Ruskin confidently says that in architecture he can distinguish servile ornament from both "constitutional" and "revolutionary" ornament. He wants only honest architecture: "Let us not tell any lies at all"—that is surely a revolution in itself. In our century the echo sounds in Frank Lloyd Wright, who says: "Simplicity, sincerity, repose, directness, and frankness are moral qualities necessary to both architecture and a good society."

The doctrine of salvation by art may be summed up, then, as a path with two branches. Art by its nature expresses the deepest and best in man. Hence it is bound to attack the wickedness of man-in-society. In so doing it manages to redeem some individuals —the self-centered ones—by the conversion of their souls through primitive or transcendental works. The warmer, more generous spirits it redeems after a conviction of sin by a vision of the just society that will come out of revolution.

I do not suppose it is necessary to speculate at length on the
84 ways in which art redeems the mentally disturbed from their de-

rangement. In that additional role many types of art are said to be frequently successful. One can easily imagine how the tapping and taming of unconscious feeling by seeing or making objects of plastic art, as well as the insight into social attitudes gained from fiction and drama, might help the bewildered and the inhibited. But before returning to the more universal question of how literally we are to take all that I have reported about the role of art as savior, we must think a little about art and religion as they existed before their great merger.

When Henry Adams wrote *Mont St. Michel and Chartres* he was certain that thirteenth-century Europe, being united in belief, found in the worship of the Virgin Mary the fulfillment that we cannot find in the corresponding twentieth-century symbol of the dynamo, that is, technology. The art of the great monuments that Adams studied and praised was the physical outgrowth of the unifying faith we have lost. Is this true or is it a projection of our desire to get from art and from life more than they can give?

Adams was wrong to think the thirteenth century united in its beliefs. No century was more divided; heresy was at its highest. But he was right in seeing the underlying scheme as familiar, ancient, and present to every mind regardless of talents or vocation. For the artist, this common platform is enough, provided he is not educated to disputation and heresy. If he disregards doctrinal divisions he benefits from the common myths and symbols. He revivifies, differently in each generation, the aspect and feelings of the well-known figures of religious history and drama. He is not obliged—as today—to wrestle by himself with conflicting systems, each of which pretends to explain life and the cosmos. And in using common material he can be understood by all on at least one plane of communication. He does not need to add

85

footnotes to poems as T. S. Eliot had to do in *The Waste Land*. That predicament began with the Renaissance and its divided allegiance: we find Dürer, for example, worrying about the propriety of using pagan motifs for his religious pictures.

A religion favors the artist in another way, by marking the outer boundary of everything larger than himself. In religious societies life is not cut up into departments. Man in medieval society is man in the medieval Church, both under one religious authority. The ancient city had the same advantageous character of *practical* transcendence, which relieves every man from the need to stand exposed, like the modern artist, as protagonist or adversary. Individualism, in short, had not done its work of emancipation from religion, of which the price is to feel alone and naked in the search for a new cosmic umbrella. The fact of a religion being *settled* is moreover essential to its desirability for art. A rising, fighting religion such as early Christianity or early Mohammedanism or the early Protestant Reformation has little use for art.

The religions of the west have the further merit of depicting life as a drama—and one centered in the individual. As regards his salvation man is free and a doer. "Works," including craftsmanship, are pleasing to God, Himself a worker in clay and other materials. For art this is a better scenario than that of science, which shows the universe to be invariable routine, matter passive, and man a product. It is not even necessary for a religion to proclaim transcendence in the Christian sense. The living principle can be immanent, as Goethe and other Romantics believed. But then the old myths must be still current—the repertory of names, parables, sorrows, and hopes. After the Renaissance it was the vast system of Greek and Roman mythology that permitted neoclassic art to continue speaking a common language, though to a restricted audience. When Wordsworth in the Preface to *Lyrical*

86

Ballads of 1798 declared that language dead, he had nothing to replace it with but the speech and stuff of street ballads. Genius in all the arts was able for a time to use popular and national materials and to find "secular scriptures" in contemporary works. That is why in the 1800s music uses titles from poems, and pictures take subjects from plays. In the end the continuity broke. Artists, in order to be themselves, came to speak their own invented idioms, less and less widely understood, and were finally driven to make a more general appeal through the expedients we looked at before—minimal art, junk, jokes, and the free access afforded by giving up intention altogether.

These considerations are not meant to initiate a "return to religion" for the sake of art. Nothing could be more silly and more certain to fail. There is no way to engineer an alliance of religious feeling and artistic power. The artists who for the last two centuries have made art alone carry the double burden and fulfill the two desires have acted under necessity. It is only their claims and rationalizations that are blamable; and not so much blamable as mistaken and unwittingly misleading. It would be pointless to subject them to analysis if practical consequences did not follow. Since they do follow, one must, on the one hand, reaffirm the *quasi*-religious value of high artistic experience and, on the other, show the inanity of the conclusions drawn from it about art and the world. Great art does produce the sudden glory and fruitful upheaval reported by its devotees; and art of many kinds, new and old, is indispensable to the good life. But the pseudo-philosophic and mystical superstructure, so far from being necessary, is illogical and dangerous.

In the first place, it is fraudulent to pass from a great artistic moment felt by one or more persons at a certain time and place to Art in general. Art does not consist only of masterpieces. Not 87

all masterpieces overwhelm everybody equally, nor do they hold their magic invariably, eternally, and universally as the litany of religious adverbs pretends. By far the greatest number of all known works of art does not inspire high ecstasies and were never meant to. The part that does inspire them acts only as a potential cause. A "bad" presentation or a bad headache eliminates the hoped-for result. Longitude east and west, nationality, age, degree of culture, cycles of taste, the strangeness of novelty—all affect the potency of art and debar it from being universal and absolute as it is said to be.

Because Art is not a singleminded power, it cannot fulfill the requirements of a religion. The priest speaks with authority to all believers, no matter what his personal failings; the artist speaks with authority only to some and only when his happy condition or theirs will permit. I know that each of us, from proprietary feelings, would like to say that *my* chosen artist, *this* divine work moves all mankind. It is simply not so. All the epithets of immortal, timeless, self-sustaining, and autonomous applied to any work are but brave lies, when they are not merely partisan publicity.

For my part, I care much too much for art as an activity and source of pleasure to make its value depend on the great experiences it periodically occasions. Art as we know it in its full extent embraces an infinity of diverse experiences, ranging from the vision of *King Lear* to the texture of an agreeable piece of bric-a-brac. We may want our addiction to be spiritually redeeming in comparison with other addictions, but our words betray the fallacy. Side by side with *great* and *sublime*, we say *beautiful, picturesque, decorative, charming*. We speak of a small masterpiece and a minor poet. We collect coins and rugs and potsherds and ruins, and we cherish them without paroxysms. In our quasi-re-

ligious moments themselves we must be on the watch lest egotism lead us—and sometimes the artist too—into a purely social affectation of spirituality, self-righteous and exemplary, as if we and a few others lived in a continuous orgasm of esthetic perception.

To be valid, the idea of redemption by art would have to be just the opposite—popular and democratic. Secular salvation, like religious, must be open to all who seek it, as Tolstoy insisted. But we know that high art is difficult and that artists themselves have tended to become technicians and specialists rather than sanctified believers. It is only in old-fashioned sentimental novels that the hero betrayed in love decides to live thanks to his violin. Real artists are not redeemed and continue to curse the world. They feel the flames of Hell and not the felicities of Heaven.

Among artists today the conception of great art for great experiences is in decline. The Futurists first, then the Surrealists were eager to deny the reality of inspiration and genius, substituting the common unconscious as the source of artistic production and satisfaction. By this shift the wish to be saved was recast as the hope that through art the barrier between the conscious mind and the unconscious would be broken down. The goal was still the unity of the self, which through its own depths would be linked with all men.

But this search and these depths are not the peculiar province and promise of art. There is no reason why art should be the only mode of spirituality. As Dostoevsky pointed out in "The Grand Inquisitor": "This craving for a community of worship . . . and for a universal unity . . . is the misery of every man individually and of all humanity from the beginning of time." It has been "the source of all religious wars and the root of all attempts at a universal state." Art is only the latest institution to be seized on, confiscated—as it were—for getting rid of the craving. And sad to 89

say, Art is of all things the worst-suited to the purpose. By its very richness and variety art cannot do the simplest things that religion, philosophy, and the state do by *their* nature. In our cant phrase, art cannot be "a way of life" because—to take examples at random—it lacks a theology or even a popular mythology of its own; it has no bible, no ritual, and no sanctions for behavior. We are called to enjoy but we are not enjoined.

In good art, indeed, rules of conduct are not even implied, the esthetic emotion is cut off from the moral. Are we to act like Antigone or Creon? Like Othello or Madame Bovary? In the painted scene is it Marsyas or Apollo who is in the right? Maximilian or the soldiers shooting him? In one way these questions are meaningless, in another not. All these figures engage our sympathies—we live their lives for a time, and live them dangerously. For to the degree that we respond we are inwardly tampered with, and in the end we become what we see and hear and imagine. As Conrad put it—and he was certainly qualified to speak for those who live by art—"Only in men's imagination does every truth find an effective and undeniable existence. Imagination . . . is the supreme master, of art as of life."

Since art brings to life in this realm of Imagination a thousand unrelated truths, art cannot be the unifier of either the individual consciousness or mankind's spiritual beliefs. Art is inescapably Pluralistic. It thrives on diversity and knows nothing of contradiction: all its opposite truths are equally true, because its type of knowledge is knowledge *of*, not knowledge *about*. Hence its power of endless growth. No one can tell what the next artist will discover and transfix as new truth, any more than one can tell him what he shall discover. He is not himself aware of his terminus, however conscious he may be of his means. This being

90 the state of affairs, it is absurd to speak of "what all art teaches

us." Even should there be such a lesson, there are no penalties for deviating from it. Members of rival cliques recriminate about each other's tendency and point scornful fingers, but the odium and flush of shame stand on the level of snobbery and gossip, not religious guilt.

In any case, a spiritual religion declines to make moral judgments and receives sinners joyfully if repentant. The division into good and bad souls is not here and now but ulterior. Art, being neither moral nor merciful, has therefore no spiritual warrant for condemning the world. Its efforts to reform mankind, as we saw earlier, were purely hostile and, innocently perhaps, self-seeking: "Whatever you bourgeois are doing, give it up and learn to love art"—presumably by becoming regular customers. All other avocations are damned by usefulness.

So far, this is the strict language of *Pilgrim's Progress*; but in going to art the painful sacrifice the Pilgrim makes and the larger scene he moves toward are missing. Art plays its part exclusively on earth, where today it feels—though vaguely—the want of something else that went with the loss of God, namely the loss of the Devil. As the Prince of the Practical he would help to take care of the Utilitarians whom art consigns to perdition. For lack of his presence has come the disuse of such ideas as temptation, the deceit of circumstance, and the ramification of appetite, which might help explain the world's misery. Only one appetite, the sexual, seems to be heard of, and it is approved. Ambition, greed, sloth, pride are deemed the product of "society" or the monopoly of other people.

How can Art, diverse and diffused as it is, remonstrate with all these miscreants, much less reform them? The artist is not and cannot be the close minister of each individual spirit, and nothing short of this relation can be reformative and religious. The artist 91

says quite properly that not he but his work is the carrier of truth. If so, the religious idea of art collapses altogether: having no unity, no eternity, no theology, no myth, no minister, its cult can only fall into a worship of the instrument—idolatry. And to say idolatry is to say failure, for what is wrong with idolatry is that it is a dead stop along the way to the transcendent.

Do not mistake me and think that I am calling the love of art idolatry. I am only dealing with the vast claims of artistic religiosity, the contention of artistic and other sincere people who say that they can no longer go to church and believe, but do go to concerts and regain faith. True believers give this notion a curt dismissal. C. S. Lewis says: "You will not get eternal life by just feeling the presence of God in flowers and music." Hilaire Belloc says: "Faith is not a mood but an act—a matter of the will." T. S. Eliot says: "Belief is something detached from temporal weakness or the corruption of an institution." Once more, art is irremediably of this world, not of the next. Its modern inadequacy as a focus and reflector of faith is not attributable to its nature or to its present creators. It is part of the loss of faith generally—faith in the state, the gods, the race, and especially in anything that is ours: our city, our government, our vocation. The very word vocation can nowadays only be spoken with irony: we are not *called* in the least.

In that frame of mind, the very inadequacy of art entices the uncritical to see it as serving the purpose I have tried to show it cannot really serve. Art is made to act as the receptacle for the shreds of old cosmic feelings divorced from propositions. Deep down everybody knows that the esthetic is really not one type of experience, but it is raised to a false unity in order to have a unity of sorts. The parallel move toward purity, autonomy, anti-moralism and anti-humanism have enabled art to avoid those obligations

92

of clear thought that any religion or morality must face at some point. The result is that except for surprise and laughter art no longer furnishes any schooling of the emotions. Flaubert's great novel *L'Education sentimentale* contains in its very title an early warning of the deprivation.

By degrees, then, contemporary art descended to the bedrock of Sensation as its last hope of giving communion to its followers. In principle the procedure has merit. The calculated coercion of the senses is the fundamental technique of all art; it determines the beholder's mood instantaneously and transforms it however the master chooses. This splendid kind of waking hypnosis has been going on in our midst for a good while now, but with diminishing returns. Widespread regeneration and refreshment should have occurred long ago. Baudelaire's invitation to this particular trip, you may remember, was to afford us

> Nothing but Order, Beauty,
> Luxury, Peace, and Sensuous delight

The competition of drugs, sex, and yogi exercises suggests that chemical or physical action is being thought more reliable.

In its present incarnations art is further weakened by excess. We continue to absorb it in the old way, naming the artist, trying to remember the title and appearance of his works. But more and more these blur into the semblance of interchangeable parts. It is often an accident of time (or the result of a planned outrage) when an item otherwise indistinguishable from the mass achieves particularity. And even then, it is as a label in the memory rather than as a source of energy to which we return of set purpose, grateful and overawed. It is reasonable to suppose that the type of shock by brutality that has become usual interferes with the

93

deeper, less obvious shock that used to make works of art seem to convey religious tidings.

The confusion by violence and by numbers has another consequence. Whatever the upshot of these assaults on our sensibilities, we are not redeemed together. It is not solely that we lack the communicative warmth that arises from the varieties of a single style agitating many minds; it is that we are thrown back too exclusively on our own resources. "See what you make of it!" says the canvas or poem. "Unchain your unconscious and 'relate'" says the theater of the absurd and the obscene. The relation is unspecified. The depths that are stirred, if any, vary in density. Even momentary gratification is a matter of luck. We would expect a religion to do better and channel the expected flow of lava. The works of nineteenth-century art that are now considered too great, too pompous and heaven-storming, at least prevented the onlooker's imagination from straying away in self-indulgence. And they did create around themselves a body of lovers linked together quasi-religiously; whereas the gayer, more modestly democratic and "disposable" works of today, content to give a nudge and leave the rest to us, succeed only in arousing what they cannot satisfy.

To this verdict there is of course the exception of revolutionary art. Its doctrine can be reactionary, theological, or anarchist: message is the unifier and director of destinies. Whoever is moved by such art knows what fulfillment to look for not merely in the next artistic experience but in human life as well.

Unfortunately revolutionary art tends to be strong in message and weak in art. All the great revolutions since 1789 have given art encouragement, but evidently not of the right kind or not to the right artists. Propaganda art has proved ineffectual as art, and the exceptions have confirmed the rule by being ineffectual as propaganda, the message being lost in the excitement of the art.

Has anyone ever turned Calvinist from even the most enthralled reading of *Paradise Lost*? Who thinks of Tolstoy's theory of history when remembering *War and Peace*? We are back at lesson one about the nature of art, which is that its contents defy literal expression. No one can say what, if any, points of doctrine he has learned from Strindberg or Shaw or Brecht—all of them great propagandists—any more than he can state what good he has derived from the non-hortatory: Rembrandt or Gluck or Mary Wigman. The generality holds for literature as well, which is not more explicit for all its use of words. The knowledge emergent from a novel is not a set of statements attractively gilded by art like a pill.

It is that image which misleads the political directors of art and the artists whom they persuade, whether inside or outside their borders. The religious dogma or political faith may well give the artist himself wholeness and confidence; but when truly communicated, these feelings come out as art and not as instruction. And since politics finds it necessary to change or reverse its views at short intervals, the relation of the creator to his work and of the work to the public becomes quite literally journalistic—a day-to-day adaptation to the shifting surface of things. When in addition to the strain of keeping up with the immediate, the artist is told that only certain forms or techniques match the philosophy of the regime, the end of art is in sight. The typical contortions of the bedeviled artist may be sampled in Prokofiev's words of 1948: "Elements of formalism were already peculiar to my music fifteen years ago. The contagion appeared evidently from contact with a number of Western friends. After the exposure in *Pravda* of formalistic mistakes in the Shostakovich opera, I thought a great deal about the creative manner of my music and came to the conclusion that such a direction was incorrect."

With these words the spontaneous genius that was to heal our 95

wounds and the autonomous work of art that was to be our heaven are buried in the same grave. By neither of the two roads that start in the sense of alienation—we might name them Baudelaire Street and Karl Marx Avenue (though each stretches farther back than these men)—by neither of those roads is Art able to reach the divine center from which redemption comes, and it is punished for its presumption. Van Gogh had an inkling of this when he wrote, "There is something else in life besides pictures, and that something else one neglects, and Nature seems to revenge itself, and fate is set on thwarting us." This something else for Van Gogh was the world of action. Heine, you remember, held to the same view and so did Shelley, in spite of his popular image as the pure poet.

The evidence that Art is quite other than a path to redemption suggests the need for a constitutional separation of "church" and art. Art loses nothing by it. Art remains a mystery, in full possession of its peculiar locus, potent, yet like man himself wayward and *insaisissable*. It does not foster a communion of saints or establish a community of love. On the contrary, under its modern sway hate seems to have increased, and nobody proposes the artist as a saintlike model for the imitation of all men. The final paradox is that after 150 years of despising society and giving signs of despising itself, art now more than ever wants to be a social force, revolutionary, therapeutic, or simply popular. Its handicaps for this ambition are as great as those that made it fail as a religion. For as Berenson said of painting, it "cannot soothe *or* cajole." That may be why art in our time has been tempted to borrow the panoply of Science. I shall try next time to say in what manner the attempt has been made.

Art and Its Tempter, Science

Last Sunday my theme was the function of art as redeemer. I discussed the individual and collective forms of salvation through art that artists, critics, and art-lovers have promulgated for two centuries. I tried to show both the plausibility and the defects of the analogy which is that the power undoubtedly exerted by great art on receptive persons is a religious power and bestows the same spiritual rewards as a religion. By the phrase collective salvation, I referred to the strong appeal of revolutionary art, which promises the artist a role first as evangelist and then as beneficiary of the earthly paradise to be ushered in by the revolution.

The connection between religion and social action—the social gospel—is very old, and the transition from religion to science has been familiar to our minds since the great intellectual battles of the nineteenth century over Positivism and Darwinism. These links account for the peculiar relations between art and science that concern us today. In the minds of the public and of many scientists, the program of science is to furnish ultimately a total account of the universe. Art, in its visionary, idealist, and symbolist phase—which is the modern phase par excellence—gives the same intimations. Indeed, it sometimes gives an outline or even a fully

97

developed system of the cosmos. Blake, Wordsworth, and Victor Hugo—to name only the great poets—have left massive works that still occupy scholars in the effort of reducing the vision to an intelligible system.

Near the end of that same century we have the remarkable example of the future Symbolist poet Mallarmé, who in his twenty-third year, after a helpful contact with Hegel's philosophy, conceived of his lifework as the wedding of poetry with the universe. Between them, he said, there was "an intimate correlation" which the ordinary uses of poetry, haphazard and given over to dreams, did not bring out. Still haunted by this vision twenty years later, he affirmed: "Everything in the cosmos exists in order to emerge as a Book." He specified: a book in numerous volumes, perhaps, but really "only one, which everybody has tried to write, the geniuses included, namely, the orphic explanation of the earth: that is the poet's sole duty."

Mallarmé did not live to write the great work, but in 1957, almost a century after his vision, his notes, diagrams, and sketches were published and analyzed by a scholar at the Sorbonne, who claimed for them the greatest importance in the theory of literature and the metaphysics of art. Mallarmé himself speaks in his notes of the "scientific relationships," expressible in numbers, which his work should embody, and which he planned to exhibit through public reading or performance, not to entertain or edify, but to "demonstrate the objective truth contained in The Book."

Mallarmé is only one poet and his ideas certainly do not commit other poets and artists; but his intention is none the less fundamental in what I am calling the temptation that science in our time presents to the artist. The ancient desire to grasp all existence as a unity (the very word *uni*verse jumps to that conclusion) and

the modern desire to communicate knowledge obtained by special

means (in this instance poetry) are the great motives of the temptation. And behind them is a specially contemporary "exasperation of frustration." Man's estate is not what Renaissance humanism hoped for and the Enlightenment predicted. The greater the progress, the more galling the limitations that matter opposes to Man's will. His loss of God does not quench his misery at not being God. Man is even beginning to feel what one writer calls "the weariness of trying to be man." State and Society appear intractable. Man concludes that there is no outlet but art or science for all his cognitive and creative passions. No third enterprise has been open since philosophy capitulated to science. Art and science thereby become dogmatizing rivals about who owns the truth—a rivalry that does not keep out envy, trespass, compromise, and confusion.

Art has always been embroiled in the question of truth, but it has never been in such a muddle as today. When Aristotle affirmed that poetry was truer than history, he meant that Greek drama offered representative cases in clarified form. Art supplied a more general truth than history. When the figurative arts were also willing to admit that they imitated nature, they could make the same claim. For representative art does not copy, it imitates; that is, renders in such a way as to make the understanding of its subject deeper, clearer, or more lasting. From Coleridge to Ruskin, the chief test of great art was its verifiability. It was the means by which Coleridge—with Hazlitt—rehabilitated Shakespeare; and Ruskin, Turner. Shakespeare's knowledge was shown to be superhuman and not wild. Ruskin accused the older painters of having "described" by tone and chiaroscuro, whereas Turner scientifically renders: "I only ask you," pleads Ruskin, "to watch for the first opening of the clouds after the next south rain, and *tell us if it be not true*." Ruskin's criticism indeed is full of references to "hill anatomy," to geology and botany: nature decides the validity

99

of artistic statements. And naturalism in literature works on the same principle—it goes without saying.

The trouble is that modern art in various ways abandoned imitation, representation, naturalism, and it now has to make out a case for its products' still being truth. This is where science—certain aspects of science—are seized upon, assimilated, or sometimes simply plagiarized in decorative words, so as to bolster up art's claim to cognitive value. One such use—and it is a curious reversal of Aristotle—is the boast of factuality: the work of the artist is said to be research; his creations are findings. A novel which won the Goncourt Prize (for the first time unanimously) and was published in this country last year, is praised as having cost the author four years of research. "Among the investigations I was obliged to carry out . . . I collected anecdotes that I would never have been able to invent, for there is very little invention in this book. Its documentary value is considerable." We have, in short, a sample of what I have elsewhere called the non-fiction novel, inaugurated by Huysmans and developed by André Gide, in which the effort is to create no illusion but that of a report. It is but a step away from the anti-novel, which also repudiates that same element of art.

This particular temptation was inescapable. The emphatic turn given to the western mind by the triumphs of nineteenth-century science and technology conferred a new value upon fact and created a new cultural type—the fact-gatherer, the fact-treasurer, usually but not necessarily a scientist—and to him went popularity and high honors. With him the artist had to compete, less for the rewards than for the chance to be listened to. The march of science might easily displace the artist as it had the divine and the philosopher. Scientists could be heard saying that poetry consisted of dubious statements dressed up in fancy words and that

100

the art of painting could not survive photography; for truth, which was a monopoly of science, conquered error and illusion wherever found. The artist had no choice but to make clear that besides the art of revelation he possessed also the art of phenomena; he too ran a laboratory and made discoveries.

This defense against the imperialism of science was made plausible by the transformation that science underwent in the 80s and 90s of the last century. It had for three generations dazzled the world with its picture of a great system of matter, visible on earth as it is in heaven, harmonious, regular, unified, and capable of being understood by anyone who took the trouble, since natural science was only organized common sense. Rather suddenly, all this changed. Science became mathematical, statistical, abstract, invisible. It was too difficult for any but those born predisposed to think in those ways. And by a remarkable parallel, the same thing happened in the arts. Impressionism, Symbolism, and subsequent movements denied the beholder simple representative effects. Imitation was forbidden under pain of indictment for philistinism and academicism. Symbol, allusion, schematic hints became the only possible modes of conceiving art. If Mallarmé had in fact produced The Book that was to reveal the universe, it would not have been a work open to direct perusal, but a carefully wrought enigma requiring the interpretation of the master—as the notes and poems extant make clear. The "objective truth" that he wished to impart called for the analysis, first, then the disappearance of the object, exactly as in science.

The progression was very much the same in painting. In Cubism, in Abstract, and finally in every variety of non-objective art, we recognize the movement of mind that took science from the lever and the lump of quartz to the particles, waves, orbits, and magnetic fields that are inferred and not seen. Existence is sym-

101

bolic and statistical, it is pure energy and bare relations mathematically expressed—which is enough: tangible matter doesn't matter.

There is no evidence that the artists who took the path away from nature to symbol were tempted by curiosity about the work of Bohr and Planck or by envy of the Nobel Prize in Physics. A pervasive sophistication (as it is called) was at work. At any rate, after this great shift the appropriation by art of elements belonging to science becomes more and more conscious. We see it first in the theory of art that ushers in the twentieth century, the theory of art as pure form, relations only. It is a daring theory, because art actually cannot get rid of its medium, which is always matter. Art stays concrete, despite the strongest urge to be as abstract and disembodied as an equation. But thanks to the earlier, well-established notion of the work of art as an autonomous world, it proved possible to indoctrinate the public with the idea that even if substance and contents suggest the visible world, they exist in the work in an entirely other capacity. Whether in the writings of George Moore or Clive Bell, Roger Fry or Albert Gleizes (the most thoughtful and consistent of the Cubist painters), the only world is the world of relationships. Gleizes defines painting as the art of "animating a surface." Bell talks of significant form. Looking back on his own advocacy a quarter century later, Bell says of his "austere definition" of art: "It is years since I met anyone, careful of his reputation, so bold as to deny that the literary and anecdotic content of a work of visual art, however charming and lively it might be, was mere surplusage."

In applying the doctrine, the serious critics confine their discussion to entities reminiscent of scientific ones—space, rhythm, asymmetry, or dimension vaguely used to suggest the atmosphere of Relativity theory. Critics and artists speak *like* scientists, not *as*,

for these terms cannot attain a comparable exactitude in physics and in art. Hence the disputes whether, let us say, a painter has or has not "allowed independent space" between figures in a certain work. It is notorious from psychology that the same visual appearances may be seen in different ways spontaneously or by an act of will. Their interpretation will therefore vary with the impression received or willed and there can be no scientific criticism of art. But the adequacy of critical descriptions is not the point here. The point is the determination of modern artists to concentrate on relations, perceived or imagined, to the exclusion of any other program—moral, intellectual or emotional.

The product desired from this discipline is pure art. Like pure science, it does not apply to the real world, but to one created by the artist, by the scientist. True knowledge, universal and eternal, is only about such worlds, not about ours. In the ordinary sense, then, art has strictly no meaning. We do find certain artists clinging to some earthly meaning, faint or fierce; but the majority emulate science in the dogma that purpose and intention are "surplusage." From Mallarmé to Valéry it is agreed, as the latter put it, that: "there is no such thing as the true meaning of a text." A poem is a structure—that word is the greatest shibboleth of the age—a structure, in which "not a single passage should have a definite sense. All statements must be so ambiguous and flexible that they shift in relation to one another" for each observer and for each point of observation—exactly as in Einstein's time-space continuum. And "the central reality which the work presents cannot be stated," any more than that of the cosmos.

Art and science alike have thus been inviting their clients to perform an unusual feat—contemplation without representation. But the consequences have differed. As long as the nineteenth-century spellbinders of science could point to the planets and the

103

Milky Way, or could descant on a piece of chalk to unfold the history of the earth, they held their audience. But with nothing to see except a blackboard strewn with differential equations, the educated man with an informed interest in science melted away. In art, on the contrary, although the rigor of a structuralism with ever sparser sensuous contents and the distilled obscurities of pure art made it impossible for an artist to be at once great and popular, the symbolic, suggestive, relational art opened up new latitudes to the unprepared imagination and a new career to the interpreter.

The result was actually a great extension of the audience for all the schools of all the modern arts. Toleration and participation increased as the forced channeling of the imagination decreased. At the office or at the friend's house, any one will stand the sight of almost any assemblage of lines and colors and will bring to it what he can. This democratic freedom is somewhat less in the arts of words, but it exists there also. The taste for nonsense verse has revived—a boon to poets—and audiences have grown for poetry readings, with no need of a corresponding growth in fullness of understanding. The same permissiveness has affected the novel, the theatre, and film. And yet this amenable art is at the same time arcane like a science. The beholder who really wants to possess it must turn into a student, a specialist abreast of the "literature." Mastery comes to him—if ever—by analytic effort, and not as formerly by going back for pleasure to what had moved him, simply repeating the pleasure and learning all he needs to know.

This state of affairs generates contradictions. The exclusion of meaning from art entails the removal of man from the center of art's concern. The likeness of man, his feelings and desires, his domestic and public actions are subjects now exhausted. Statistics

take care of them. In this decontamination science again led the way. It made rapid progress only when it banished man from its reckoning, together with all anthropomorphic ideas. It then had a universe free of meaning and purpose, which it could reduce to abstractions that were alien—and even contrary—to common experience.

But the removal of whatever is man-like from art after its elimination from science leaves man himself with no shadow of a pied-à-terre; and many humanists have cried out that the survival of mankind requires a reduction in the dose of abstraction, and a reconnection through art with the founts of human instinct. "Nothing less is required," says one critic, "than the subversion of the scientific world view with its entrenched commitment to an egocentric and cerebral mode of consciousness. . . . There must be a new culture in which the non-intellective capacities of personality . . . become the arbiters of the true, the good, and the beautiful."

We have come back full circle to Schiller's essay of 1795, in which the spontaneous genius was to save us from self-consciousness. Some of our contemporaries have heeded this summons. But the habit of system, structure, and deliberate contrivance which science has bred in us is hard to shake off. Spontaneity-to-order is a contradiction in behavior as well as in terms. When we find the "spontaneous" in music or fiction making much of drugs and sex, we recognize an instrumental technology for breaking jail, and not the native spontaneity that was called for.

Besides, the environment we have created for the arts is not favorable to the freedom that the anti-rationalists want to recover. Long ago, the critics and the public teased the artist into giving an account of himself. The artist was tempted and turned pedant. Read the interviews with young and old before an opening, or

105

scan the creator's "statement" in the printed notes or program, and you see how lacking in "autonomy" the artist is, whatever his productions may be. His views most often consist of jargon patterned on scientific or metaphysical discourse. It has to sound distinctive and profound, it must suggest heroic grappling with problems hitherto unimagined and now at last solved.

This scenario, again, is taken from the romance of the scientist. And so, of course, is the now accepted notion that there is such a thing as experimental art. The pretense is of course absurd. But I know of only one artist in this century who has ever called the bluff. It was Edgard Varèse, who said: "When I produce a work my experiments are over." They are not experiments, in any case, but trials, which are common to every manual and intellectual activity. The aura sought in the longer word is but one more borrowed plume. The rest of the tail feathers will be found in the similarity pretentious naming of works. Most artists do not distinguish between science and technology and adopt indifferently the nomenclature of the workshop and the laboratory. They call a piece of sculpture: "Innovation 23," a dance: "Event 66," and a piece of music: "4′ 33″," which (by the way) is a three-movement silent composition. Mysterious labels, such as Beyond Geometry or Optical Acceleration, are stuck on quite simple objects, to lend the enchantment of the technical. The popularity of "workshop" itself among "experimental" theatres and summer schools of "creative writing" is a sign of the debauch, not of words alone, but of frantic emotion. It would be trivial if it did not point to the predicament of the artist and his well-wishers, who find themselves called upon to give knowledge, give salvation, make revolution, create worlds, solve problems, discover the unknown, and certify it all with the hallmark of science.

It is true that art and technology have a natural affinity, and

the plastic artist especially can press into service new materials and let them inspire new effects—as the public saw on a large scale at Los Angeles in 1971. But more often technological chic stops at bestowing new names, for example "cemations," which at the cost of violence to language is supposed to mean solid works of cement. Or again, much is made of new methods: I mentioned earlier the reproducing of classic works by stencils and sprays. Finally, there is the attention-getting value of producing works in series. So-and-so is no longer working at squares or verticals; he has shifted to ovals after a short period in circles.

I call it attention-getting in no derogatory sense. Art has a right—indeed, a duty—to call for attention. But the stress on series, and possibly the series itself, introduce a new criterion. I mean the Interesting as an esthetic category. Though conspicuous in the visual arts, the Interesting has general sway over them all. Listen to talk about any art in the milieus most concerned: the word continually in the air is "Interesting." It is the first word about the new and usually also the last. The idea it contains is related on one side to the offbeat, the Absurd, the Minimal or any other form of the unexpected; and on the other side to the pre-occupation with science and technology, whose novelties are marked by Interest alone. What is the Interesting for this age? I suggest that it is a compound of surprise with amusement, a challenge to the analytic attention, an acknowledgment of ingenuity and skill, plus a resolve to make a mental note of the method or principle at work and to remember the artist's name. Yet interest even survives the absence of the artist. The interest of found art or junk art is that chance can make these forms full of *equally interesting* internal relations without the intervention of human hands or brains.

Another way of accounting for this respectful scrutiny would 107

be to say that in the contemporary arts we respond to technique, to technical innovation, beyond any other appeal. Such an attitude has always been normal among artists of the same craft. Their eye or ear is caught by the other fellow's new dodge and they exult or dismiss according to their own plans or fears. We know from artists' letters and recorded confidences what part or effect struck them in the new masterpiece before it bowled us over, and as we compare our comprehensive response with their absorption in a detail—to them enormously *interesting*—we measure the difference of outlook between artist and public. The increasingly technical interest that our century takes in works of art means that the artist and his public meet on a new ground, no longer of personality but of method. The beholder's approach is friendly and conscientious rather than passionate.

As part of technique one must note the continual references to "solving a problem," as if the state of the discipline required a breakthrough. The fact is, there are no problems in art and no solutions. A true problem has set terms, identical for all workers, and the solution removes the problem. In art, there are *difficulties*, which must be overcome again and again, and differently by different artists. Those who work to formula, even their own formula, we think very little of. You may say that the difference between a difficulty and a problem is only verbal and that I am making too much of a *façon de parler*. I would answer that modes of speaking throw light on hidden feelings and that the solemnity with which artists and critics speak of problems reveals a self-importance borrowed from the worst of scientist rhetoric.

Consider in this light another example of the distortion brought about in art and in opinion about art by an unexamined idea, also borrowed from the scientific sector. I have in mind the pseudo-standard of functionalism. Functionalism and the "truthfulness"

of design associated with it belong properly to machinery, which has definable functions. Art and architecture have many functions or none, depending on circumstance. When several functions can be named, as is true of most buildings, which function shall be controlling? In a hospital, the staff and the patients make opposite demands. In many objects looks and convenience lead in opposite directions. A house, in spite of Corbusier, is not a machine to live in, precisely because it has to suit a large number of contradictory needs. And any compromise can be called a fault or a merit arbitrarily. The leaky roofs of a famous "functional" architect of the last generation are notorious and are usually pooh-poohed as trifles by his admirers. Yet keeping out the rain would seem to be one function of a house.

As for the canon that honest architecture should not tolerate visual deception about structure and inner functions, it is broken by the greatest examples of classic, gothic, and modern architecture, including some of the superb nineteenth-century railroad stations that have begun to be duly valued esthetically. The human body itself, which is generally believed to have some visual and architectural merits, is not altogether honest in its disclosures and is even thought to become repulsive when flayed to expose its functions. Functionalism, if strictly propounded and not a mere synonym for bare walls, is a piece of false rigor aping the scientific style. The error must be apparent to anyone who reflects that if ugliness (however defined) is a defect in anything man makes, then its being useful and functional is not a sufficient proof of rightness.

To speak of reflection and pose questions of right and wrong reasoning brings up one of the most difficult and most fundamental subjects involved in an examination of art. Has art anything to gain from the artist's possessing ideas? Should artists permit

109

themselves to entertain those dangerous things? It is a proper assumption that ideas are equally accessible to everybody and that once admitted to the mind they retain their identity and significance. Ordinary conversation does bring out what used to be called cross purposes and is known today as "semantic differences," but the phrase again supposes that misunderstanding comes from applying different words to the same unchanging thing; whereas the trouble comes from disparities in the quality and scope of the ideas themselves—vivid or dim, rich or shriveled, clear-cut or fuzzy, well linked to legitimate implications or loosely wandering. The upshot of these possibilities is recognized in the common distinction between a thinker and a non-thinker or poor thinker. Yet we assume that the possession of ideas means the capacity to think; we expect the habit of thinking from anybody who shows signs of "having ideas."

On this account, the loyal lover of the arts is apt to grow indignant when told that relatively few artists can think. I mean think abstractly, think competently about the ideas afloat in the world. Every artist worthy of the name thinks admirably about his craft and his materials, as we can tell from the result. But there is a capital difference between the two modes of thought. The thinking that goes into art is rarely abstract and need never be articulate; it need not emerge as idea at all. Ask a musician or painter, Why do you do this? Why don't you do that? What's wrong with So and So's color system or counterpoint? and the chances are that you will not receive a clear or satisfactory answer. The true answer lies outside the realm of anybody's ideas. It would take a man who was both artist and theorist—in short, a fine critic —to think out the answer and make it intelligible. This is the reason why artists' statements about their work and that of others should hardly ever be taken literally. What is said is important

and may be illuminating, but it has to be studied and interpreted. Handling ideas is not the artist's *métier*.

The exceptions to this generality occur at once because they are so conspicuous. Leonardo's Notebooks, Delacroix's Journal exhibit the minds of great artists who were also remarkable thinkers. So do the writings of Berlioz and Wagner. But in the writings of less powerful minds, we soon distinguish the treatment of ideas about art from that of ideas about everything else. In the marvelous letters of Van Gogh, for instance, whatever concerns painting and literature shows a greater grasp than what concerns society, business, and human character. Let me repeat that this difference may not reflect Van Gogh's *understanding* of these mundane subjects; it reflects only his inadequate expression of his understanding, or even more likely his borrowing of ready-made ideas.

With this observation we return to our main subject, which is the perpetual temptation that current ideas offer to artists; and not only the contents of these ideas but their form, tone, and market-rating of the moment. Taken up as formulas requiring no further work to make them useful, "ideas" are a particular menace to artists, to their work, and through it to the public. "Further work" on the idea would mean an effort to imagine vividly and accurately what follows from a proposition—how and how far it should modify action as well as the remainder of one's ideas. For example, a few years ago a number of architects in this country came across some works of sociology and discovered there that the inhabitants of large cities suffer from a deprivation of the sense of community. The technical term is *anomie*, which implies anxiety caused by social isolation. I once heard two leading architects discuss this important idea, which was new to them, and conclude that the recent innovation of not enclosing the entire lower floor

111

of office buildings, thus permitting pedestrians to walk and meet under the resulting arcade, would do much to restore the city dweller's sense of community. And they went on to say that new buildings for city universities should be built on this plan, in order to make the neighborhood feel enthusiastic once more about education and scholarship.

What was at fault in these minds gifted with three-dimensional vision was not the warm impulse to serve the city dweller's inner needs, but the lack of consecutiveness and fertility in the images stimulated by that impulse. To think that crossing the path of other busy people under a building, instead of around it, would cure a deep-seated emotion inherent in the lonely crowd is not to think at all. The same is true about the proposed cure for the hostility of town and gown. And to fail to see that at night these new open spaces with convenient pillars and shadows would assist mugging and other city crimes is to neglect the primary duty of thought, which is *to imagine realities*. The second duty is to be cogent, to test any part of the thought with its antecedents, cognates, and opposites.

This example may seem trivial, because of the disproportion between the important aim and the insufficient means. But it is the very triviality of the bond between some notion and its consequences that makes "ideas" an ever-present threat to artists. Ideas with no roots in imagination and no stout links to other ideas are nothing more than attractive toys, especially when they shine with the authority of science or social science. Yet such whimsies may determine the design of a building, the vocabulary of a poem, or the incidents in a work of fiction. We saw earlier how the Russian censors, imbued with an idea or perhaps two, forced Prokofiev to admit that western formalism had seduced him into composing music out of tune with the revolution. "Formalism is

counter-revolutionary"—a grand idea on the face of it. But what, by the way, is Formalism?—Never mind! It's a word and must be an idea.

This pattern underlies most of the borrowings from Time-and-Space science that are found in painters' declarations and all the borrowings from Freud and Jung that are thought to make novels and plays modern, true, and profound. For in scientific ideas as in those of politics what is inimical to art is their transformation into virtually live agents. Politics give us formal*ism* and devia-tion*ism*. Psychology gives us the Oedipus complex and the *imago*. These are descriptive names covering many individual acts; but the artist unused to self-defense against ideas puts his trust in these verbal beings rather than in the actual beings under his eye. In so doing he acts precisely like a scientist: he finds greater truth in the general than in the particular. He forgets Blake's aphorism: "To Generalize is to be an Idiot. To Particularize is the Alone Distinction of Merit. General Knowledges are those Knowledges that Idiots possess."

Blake was always vehement in repelling science, and we do not have to call "general knowledges" idiotic in order to see that he was right about art. Consider an English play of the mid-sixties entitled *Saved*, in which occurs a scene that attracted a great deal of attention when produced. A baby wheeled in a pram in a London park becomes the butt of several adult hoodlums, who egg each other on to badger the infant, who then roll it about in its own excretions, and finally kill it by hurling stones at it, while one man urges the others to urinate on it. In an interview with the press the producer congratulated himself on having won the right to stage a scene of such originality and significance.

The author, fortunately, has provided a Note to the play to tell us what this significance is, in relation to his other ideas. The work, 113

he says, "is almost irresponsibly optimistic," because "the chief character is naturally good" and remains so despite his bad environment and what he undergoes before our eyes. The drama, we are further told, depicts "the tragic Oedipus pattern," but the young protagonist turns it "formally into a comedy by not playing his traditional role in that pattern." In the first scene we see him a victim to "sexual insecurity." At the end, having endured much from "people at their worst," he has "created the chance of a friendship with the father" and he "has not lost his resilience." That last trait is shown by his willingness to mend a chair.

So much for Oedipus, to whom I shall return after we have learned the justification for the great murder scene previously described. The author gives it in these words: "Clearly the stoning to death of a baby in a London park is typical English understatement. Compared to the 'strategic' bombing of German towns it is a negligible atrocity, compared to the cultural and emotional deprivation of most of our children its consequences are insignificant."

In these twenty lines the playwright lets us see how he thinks, or rather, how he uses these many social, political, philosophic, and scientific ideas. "Sexual insecurity" is for him a force that acts behind what we see and on which he can "build" an opening scene. The ideas bears the same relation to behavior as the mending of the chair bears to resilience. As for the tragic Oedipus pattern—another agency—one would suppose it irresistible by definition; but here the mechanism breaks down, thanks to the youth's resiliency. Why then was Freud's formula invoked at all? The puzzle deepens when one is told that the hero comes to see his faults by recognizing his "ambivalence" at the stoning of the child and his "morbid fascination with it afterwards." In short, we are asked to believe that this wretched youth in the worst pos-

sible surroundings is analyzing himself well enough to resist Oedi-
pus and remain naturally good. What goodness there is in his am-
bivalence and morbid fascination is not explained.

The see-sawing between the artist's first-hand observation of
characters and his "general knowledges" is the reason why the
play is representative of art overtaken by ideas. This judgment is
borne out by the great scene. We have heard the author rationalize
the stoning as a "negligible atrocity." He commits the fallacy of
thinking numerically about moral facts. The ratio between two
orders of magnitude—one baby and thousands bombed—seems to
him to *reduce the quantity of atrocity* contained in the child's
murder. This pseudo-scientific measurement is one of the common
errors of the present world, from which our artists are the very
people who should rescue us. The unthinking repeat the cliché
about the infinite worth of the individual, but are stirred up only
when there are enough individuals to bother about. I quite under-
stand how we are driven to lead statistical lives, but I repeat that
it is the duty of art to make us imagine the particular; to make us
understand that the rights of one human being are not a fraction
of the rights of more than one, and at the same time that in any
situation of collective evil, the suffering is *felt* by no more than
one person; only one feels the bitter agony of injustice, only one
dies. Consequently the massacre of a hundred people is not a
hundred times more wicked than the wanton killing of one;
neither is negligible; they are equal. Evil may be repeated, but
is not added up or multiplied. The playwright's notion of a "negli-
gible" horror would bespeak heartlessness if it were not so clearly
a case of Blake's "idiocy of general knowledges." It accounts as
well for the frivolous thought that the amusement of stoning a
baby among friends can serve as a symbol of war or of man's
inhumanity to man. "The scene is typical of what some people do 115

when they act without restraint. . . ." We can well believe it, and that is just why we cannot then go on to equate this torture for fun with the "cultural and emotional deprivation of our children."

This example of ideas bungled and misplaced reminds us of the modern mania for metaphor. Figurative language is today a temptation which the artist's inability or disinclination to think renders fatal. He is led on by the example of science, which is increasingly metaphorical on top of its mathematics: think of the "genetic code," which is not a code at all. Some scientists, recognizing the remoteness of science from common sense, have gone so far as to say that science cannot be a description of the universe: it is only "a metaphor" about it. The artist also finds that social science, imitating science, multiplies metaphors about elusive human affairs; and he himself, gifted with metaphorical speech and symbol-making power, but ill-equipped for ideation, ends up a contributor to the debasement of speech and the confusion of his own domain.

You may say that metaphor is hard to avoid; language is heavily metaphorical. But the fact that we mostly forget it is important. The dangerous metaphors are those made up on purpose to enlarge our understanding or redirect our feelings or sometimes only to kick us awake. A particularly objectionable example that occurs to me is to speak of the "rape" of a country. Another is to refer to dictators as madmen. These metaphors cut down the chances of subsequent thought. A madman is not responsible for his acts, so if tyrants are mad, they should not be blamed. A rape is not followed by economic exploitation and the compulsory learning of a foreign language, so the point of the comparison is no more than is meant by sudden attack.

Scientific metaphor may find its own corrective, but in the arts

116 metaphor is often the active substance and not merely the terminol-

ogy. I would hazard a guess that the author of *Saved* was consciously or unconsciously influenced by Blake's aphorism "Sooner murder an infant in its cradle than nurse unacted desires." This potent image is a valuable contribution to moral knowledge; it could certainly inspire a scene on the stage. But when translated into action without due imaginative logic, it projects around the idea a cluster of irrelevancies each of which may serve as a pattern for violent behavior in the actual world—witness the English Moor murders, in which some adolescents tortured and killed a pair of small children, without purpose or hatred or much feeling of any kind. Neither Blake nor anybody else can be charged with responsibility, but ideas travel easiest from point to point by imagery, so that their greatest propelling force is necessarily art.

The description I have so far given of art envious and imitative of science has to be qualified by mentioning the reciprocal. Science envies art and makes frequent noises and gestures to suggest that it *is* art. The mathematicians—Bertrand Russell for one—often assert that their works provoke esthetic emotions and are in fact ruled by canons of elegance, structural beauty, and the like. Others make the point that art and the highest science are equally pure, useless, done for art's sake and the joys of contemplation. And some go still farther and assert that no great work is possible in any branch of science without a poet's vision of that branch.

To all this we may pay formal respect by acknowledging that the human mind is one in its comprehensiveness and that the rational and imaginative power displayed in its greatest achievements, artistic *and* scientific, is also one and the same. But to say this is not to say that the products of that power are substantially alike. A mathematical demonstration has beauty of form only in a metaphorical sense. One has never heard of any hung on a wall

117

or recited in a theatre: it lacks sensuous appeal. A lover of mathematics can remember its so-called elegance in full without going back to it as an object; whereas all art is some object.

A demonstration moreover—or an experiment—is reproducible at will by a merely trained mind, as a work of art is not. I question, too, whether the elegance of one piece of scientific work is not the same general elegance as that of another piece of similar quality and complexity; whereas in two poems or two dances, each elegance is particular. We come back to this essential feature that art particularizes. Attempts to use art for conceptual purposes—philosophic, religious—in the manner of Plato and Hegel are permissible, of course, but by definition they leave art behind; esthetic contemplation in science has the same thinness of texture.

I would add that if one is looking for thrills out of the contemplating man's mental powers, it is provincial to stop at art and science. Statesmanship, military strategy, and even more emphatically the codification of law provide examples of imaginative genius equal to any other. Yet they are not art. There is no reason to say that before Blackstone or Bentham could proceed with his task he had to have a sculptor's vision of the writ of habeas corpus.

Having got free of the dogma that science alone can rival art and share man's admiration for himself, we reach the last of the activities that subject art to the scientific influence. I mean Criticism. It is a vast enterprise, on which I must content myself with a very few observations. Though artists say that they and the critics do not understand each other, they talk the same language. The scientism one finds in the declarations of artists come more often from reading criticism than from reading the General Theory of Relativity. The prevailing mode of criticism is analysis and its medium is pretentious jargon; that is, the critic undertakes to do with the work of art what the scientist does with the cosmos

118

—exhibit its structure. The critic does this with a terminology which is suitably abstract though not as yet agreed-upon. Structure is naturally not something to be simple-minded about; it is intricate, hidden, and hard to demonstrate, even when analyzed to one's satisfaction. Hence the long controversies among interpreters, each of whom hopes like a scientist to contribute an unchallengeable bit of theory to the grand edifice of analysis. I remember, for instance, an article detailing fourteen earlier analyses of Blake's "Tyger, tyger, burning bright," all fourteen evidently on the wrong track. Analysis turns on minutiae and as in the world of nature leads to paradoxes. Thus a novelist-critic can come to speak of "Language as a fictional character" and another can isolate like a microbiologist the "type of anxiety crisis necessary to give fiction authenticity."

In the figurative arts critical analysis suffers from the diversity of terms and their lack of both solidity and fixity. That the situation is no better in music, where technical terms are plentiful and reasonably well defined, proves the difficulty to lie in the ambition of the analysts. For example, a musical journal of advanced views sums up what went on at a discussion of notation by saying: "Psychology, acoustics, and phenomenology, yes, but very few problems of practical performance." The virus of theory-making is endemic. The journal then goes on to report the "socio-political approach" to notation, from which it appears that the notation we use embodies "the traditional concept of the composer as supreme ruler, enslaving the performers by means of a notational system that deprives them of the exercise of their own creative capacities—a symbolic representation of autocratic capitalism."

Overlooking the factual error about the composer tyrant, one may say of this type of thought that the surrender of criticism to pseudo-analysis by borrowing the forms of scientific utterance 119

serves art and artists very poorly. It accustoms them to the habit of generalizing from a few impressions, of elaborating in long words the short supply of what they already know, and often distorting truth thereby, as in the remark I heard that composers "give auditory information." Such phrases are not more precise for being abstract and newly coined; they are technical only in appearance, like the rest of the jargon in which most of our activities are awash. Pedantry, intellectual inflation, loss of grip on reality and its contours characterize the critics' medium, in a vain effort to achieve the authority of science.

Here is an example dating from the 1920s, when the pernicious habit got into full swing. The passage deals with the work of Henri Rousseau (the Douanier), the comments on the jargon being interpolated by an early objector to the malpractice:

—For Rousseau a painting was a primary surface on which he relied physically as a means for the projection of his thought. [*Translation*: Rousseau wanted to paint on canvas]—But his thought consisted exclusively of plastic elements. While structure and composition constituted the base, the pictorial substance was distributed gradually as execution progressed. [*Translation*: He painted while painting, since one cannot cover the whole canvas at one stroke] —In his work, what simplicity! Nothing descriptive—only surface relations on the given primary surface. These relations are infinitely varied and, without losing their inherent reality, they can also compete with nature within the limits of the painting. [*Translation*: He drew natural objects in two dimensions, or, to avoid tautology: he drew objects]—Rousseau does not copy the exterior aspect of

120

a tree: he creates an internal rhythmic whole conveying the true, grave, expressiveness of the essentials of a tree and its leaves in relation to a forest. . . . But his style was established neither derivatively nor in obedience to fashion. It stemmed from the determination of his whole mind as it incarnated his artistic aspirations. [*Translation*: Rousseau painted just as he liked and he liked painting trees]

I need hardly point out that this mode of non-thought is the counterpart of the vulgar promoter's effort to dignify and aggrandize; it is the trivialized imagination that transforms the bed-sitting room into "a living area." It is the very opposite of the artist's love of the particular.

After an immersion in even subtle and sober analysis it is hygienic to go back to the artist himself and his spontaneous thoughts, if one can catch one who has not succumbed to the blight of scientism in its myriad forms. I turn to Van Gogh's letters, for example, and being careful not to take any remark as definitive and apodictic, I find myself gathering a bouquet such as this:

"There are hidden harmonies or contrasts in colors which involuntarily combine to work together and which could not possibly be used in any other way.

"I want to paint men and women with that something of the eternal which the halo used to symbolize.

"When Paul Mantz saw . . . the violent and inspired sketch by Delacroix . . . 'The Bark of Christ,' he turned away from it saying, 'I did not know one could create so much terror with a little blue and green.'

"I am crazy about those two colors, carmine and cobalt.

"I am always in hopes of making a discovery there [in colors], 121

to express the love of two lovers by a wedding of two complementary colors, their mingling and their opposition, the mysterious vibrations of kindred tones."

The last word on art should indeed be: mystery. But that need not stop any of us from dealing with it as if we understood more than we can. Art is a vast uncontainable energy, but as I shall try to suggest in my final talk next Sunday, the uses of it are not altogether beyond our control.

Art in the Vacuum of Belief

LADIES AND
GENTLEMEN:

You and I have taken a quick five-hour trip together through a rich country, in which clearings and cultivated lands occur side by side with jungles and swamps, and now the time has come for me to give a synoptic account of the exploration. *Your* impressions I very much regret that I cannot hear, though perhaps it is better for me that I should not. Your patient listening for one more session will, I hope, be justified by my attempt to bring together some ideas of possible use to you in resolving the large question with which we started: what the use or abuse of art does to life in our time.

I began by citing Nietzsche as a critic who had asked the same question about history, and I end by borrowing from him another convenient phrase about art. The role or purpose of art, said Nietzsche, is to enhance life. In so saying he summed up the whole nineteenth-century outlook which we briefly reviewed. From the Romantics onward, art was supposed to deepen, enrich, distill, refine, ennoble, redeem life. This diversified aim would not be distorted if one said simply that to enhance life is *to make people livelier*, to increase in them the concentration and force of the vital spirit.

123

But why should the effort be necessary? What need of art to revigorate mankind? The very definition of life is that it asserts itself. Anything that lives makes a claim on the environment to keep itself going, enable itself to grow. Life has the self-regard and self-confidence needed to seek out and assimilate food, air, sunshine. It surveys the world not with fear sometimes tempered by hope, but with hope sometimes tempered by fear. Life believes in itself first, long before taking thought. Therefore to enhance life through art must mean from the outset to increase hope and self-confidence, to reduce fear and self-doubt, not the reverse.

If art and life are to fulfill these conditions—I say IF this is the program—then looking about us today we must say that life has lost momentum and that art as we find it and use it is not performing as enhancer. Life lacks self-regard and self-assurance and does not provide art with satisfactory material to work on. Art retorts by condemning life, by persecuting any manifestation of self-regard. The net result is: we who make up the contemporary world are not lively—at times, one is tempted to say: not life-like. We are certainly not in love with life. We do not think life can be noble or even good. We take human life and our present view of mankind as equivalents and are not pleased. When we speak of the human condition we mean something execrable, a prison sentence we must endure. We seldom find among men individuals to revere, and we have nothing but scorn for social types, which we now call roles, as if to emphasize their falseness. The very word reverence has come to connote a benighted, "unrealistic" frame of mind. The hero has disappeared from fiction, from history, and from life. Art is largely devoted to showing the contemptibility of the human animal or, by pointedly neglecting him, his irrelevance and superfluity.

124 Nor is this repudiation directed at the single specimen or type.

Art fights just as relentlessly against the large groups, classes, masses, nations and their institutions. The point that our society, our civilization is vicious and absurd is brought out directly as well as by an inversion worthy of the 90s: we are told, namely that aberration, crime, madness, and sloth are the last gestures of reason and virtue, both of them hounded and defeated by things as they are. The monopoly of artistic insight itself is lodged with the mad. As Vladimir Nabokov, at the launching of a new book, said to a reporter: "I have never seen a more lucid, more lonely, better balanced mad mind than mine." This hardly improvised verdict on himself can cause no surprise; we acquiesce in the artist's boasting of madness and lucidity together.

But more important than the paradox is the fear behind the pose, the fear of being caught in a belief. Any degree of self-acceptance would be an acknowledgement of the power of life, with all the risks involved. Lucid mind and mad mind and the merit of loneliness are claimed so as to hedge a poor bet. This shuffling stance is not new, and judging from its frequency among our *aristoi*, not easily avoidable. It marks the supreme degree of self-consciousness, which has become the ruling passion: the mind automatically rejects anything that might imply confidence, much less self-confidence. Now confidence is a word built on the root meaning faith; absence of faith, its studied rejection, is the warrant for my calling our peculiar situation a vacuum of belief. It differs radically from the old sorrow at the loss of a common underlying belief; it is not the distress of facing a chaos of warring beliefs; it is not a painful skepticism about a remnant of strong beliefs; it is the inbred avoidance of the risks inherent in any beliefs; it is a flight from the sensation of belief—and therefore from life itself.

The forces that have produced this void are many, but as I

125

hope to have persuaded you, art has been their most powerful medium. Deepening and spreading self-consciousness by analysis and corrosion has been the function of modern art that made me call it a destroyer. It was then clear why art could not cure the wound it sedulously kept open. Art is not a religion; it cannot make promises of grace, or fulfill them if it made them. Art is of this world, and though it is creative and formative in the exact sense of those words, it is also reflexive. In some fashion, crude or fine, it reenacts our lives—the hidden life, or the public life, or the collective life. As Henry James said: "art is our flounderings shown." And in the light of contemporary art one must even say: our flounderings shown *up*.

That invidious, resentful relation of art to life has become general and unremitting. It obtains even when it is not immediately visible; and it dominates the field through a division of labor. Not all artists reflect all of contemporary life. Some, for example, respond to the dwarfing of man under mass civilization by banning the lovable from all fictions. Others respond to diagrammatic science by painting esoteric rectangles or revolting parodies of anatomical specimens. Still others pick up the refuse of practical life and shove it under our noses. The reflex, as I have termed it, is by no means always literal and by definition it is only in part deliberate. The reality, whatever it may be, palpable or invisible, goes into the eye or the mind's eye and comes out as work of art. The conscious mind of the maker may have found his governing principle in technique or in the work of others or in political or sociological doctrine—no matter: the origins are in some portion of common experience. Art re-exhibits it in some mood—anger, contempt, derision, indignation or no less eloquent impassivity. Art knows best what we are like. A particular work or artist may err, especially about details, but art as a whole works its will on

126

its contemporaries by using their helpless disclosures as evidence against them.

Such is the setting for the present conflict between art and life. In describing it as I have done, it may seem that I am contradicting myself. After demonstrating through five lectures that art has been moulding the receptive spirits to its own pattern, I am now saying that these same spirits have been the unconsciously determining element in the animus of art against the world. Both statements are true; there is no contradiction. Art and the world are conditions and consequences of each other. Art imitates nature and nature imitates art. The wedded life of art and society is the union we call by the single name of culture, and it is the possibility of considering it now from the side of action or life and now from the side of reflection or art that gives meaning to my theme—the uses of art. Because among us art and society are at odds yet mutually dependent, each can disturb and modify the other. Modern architecture and the huge city form one obvious example. The tall building makes for the large city and becomes its symbol. Then the large city revolts and decries the tall building as inhuman and its influence as coercive. Ways are sought to combat the influence and rehumanize the city. But it is the same men who make and use the architecture, overuse it, and end by decreeing its disuses, as by zoning.

In the arts that express more than gregarious or practical desire, the interaction may not find any limits—any zoning. That is why, in the time that remains to us, I want to define some uses of art that you may think amount to an abuse. These and their opposites constitute a sketch—the first so far as I know—of a general theory for the institution of art.

As I promised at the outset, I shall as far as possible frame my suggestions in the hypothetical form "if-then," thus leaving you

127

free to decide what you wish to see happening in art and society conjoined. This very idea that you have a choice may strike you as fantasy. You doubtless believe that you submit to whatever art blows your way as you do to wind and weather. But if you ask an artist he will not agree with you. He will maintain that *he* submits to your caprice—or more politely to your taste. He will ascribe to your insensibility, ignorance, and stiff-jointed habits the resistance he feels to his creative will. He blames you for plans defeated by prejudice and works blemished by compromise. He thinks, in short, that you are the sieve of natural selection which determines the survival of contemporary works, schools, and men.

He is right to give greater weight to opinion than you as an isolated member of the public are disposed to grant. Yet though you never feel its force or its absence, nothing kills or promotes quicker than the word-of-mouth. The gross example is of course the best-seller, but the same mechanism is at work in the most off-track circle. Its most frequent effect is that of artistic rehabilitations. In my time I have seen Mozart and Henry James lifted from the status of empty, frivolous virtuosos to that of great and deep geniuses; El Greco rescued from a negligible place as a baroque artist; Berlioz raised from grudging toleration to the highest eminence; Italian opera recognized as permissible to attend; and the Cubists credited with sole seminal power in our century. All these conclusions began by being ideas in solitary minds, lone dissenters from the crowd. It follows that what you think—what you decide and keep firmly in mind is of the utmost importance. Before you know it, your conviction comes out in attitudes and words, which in turn start echoes and arguments distant from your own corner, and after that anything may ensue. The incalculable upshot of encounters among public thoughts, the side-effects of boredom and novelty-seeking, the defeats and victories of ideas

relevant and irrelevant—all these produce alterations and fixities in what is finally summed up as the temper of the age.

Begin with a simple situation directly related to our main subject: the Supreme Court in its decisions on pornography expects us in effect to decide between what is obscene and what is art. The criterion is: redeeming social value. If you hold clear ideas of art as redeeming, through either its spiritual or its revolutionary force; and if you have made up your mind what the purpose is of depicting sex, or of depicting it in certain ways; and if your reason and feelings agree about the quality of speech you want from literature and drama, then you can begin to decide the question put to you by the Supreme Court. It is put to you individually in the sense that the standards of the community are invoked as guides to what is socially redeeming. I need not labor the point that if you never trouble to think about art in society or about the way art reflects and moulds the feelings of living men, your judgment on a piece of pornography is no judgment at all, but a superstition or a thought-cliché. Its being favorable or unfavorable leaves things as they are.

Next, let us consider the matter of style. It is odd that the principal use we make of the word is in the phrase "lifestyle." The term rarely refers to art with its former honorific value, as in "this work has style." It is used merely to mark small differences in a person's mode of life, with no suggestion of special merit or quality. In culture at large, it is a long time since a single style has prevailed in any art. These facts pose one of our hypothetical questions: if a period lacks its own style, as well as a sense of style, then the sum of art produced will probably not exert any clear or subtle influence. The influence is scattered; the scattering bewilders. The observer, no matter how devoted or intelligent, has to make a continual effort to re-unify divergent impressions in his sensibility and

129

thus waste a part of his power of attention, his readiness to absorb, his intake of pleasure.

What is more, the general attitude towards art gradually deviates from intimacy to curiosity. One surveys, explores, collects, and thence, by necessity, one studies—which may not be the best way to receive the ineffable messages of art. The advantage of having the art of one's own time concentrated through one style—or one dominant and one upstarting—is that it heightens the sense of collective power and achievement. There is nothing like fresh art—or fresh eggs—to enhance the belief in life. New art, assimilable while still new, makes the beholder feel possessive about the whole effort of art; he learns its peculiarities and innovations by osmosis rather than brainsweat; he fights his immediate cultural ancestors with the support of the geniuses who create the new art, and he takes sides among these creators on the strength of subtle differences that affect not merely eye and memory, but heart and spirit, too; these differences become part of his mundane convictions and habits. In a word, the association of art with life is close and continuous, as it was for the generations before 1920 when the dam broke and styles, periods, fashions, avant-gardes, and retrogressions mingled in one flood.

If collective enthusiasm for contemporary art is desired, then some stylistic clustering and some steadiness in production are required. Freedom and variety are not excluded, but the battle at least is joined and intelligible, as it cannot be in a melée. Remember how much we now face: all the classics from the caveman onward, all the moderns from the last century onward, and all the styles of all the tribes brought from the ends of the earth westward. The succession and simultaneity of avant-gardes form a jungle in which all but Mowgli and Tarzan lose their way.

130 The disposition we make of the classics, I shall deal with in a

moment as being peculiar and indicative of our state. Tribal art, of course, necessarily lacks the immediacy afforded by one's own style. We think we experience the primitive with our full esthetic powers and the rich background of western art, but a multitude of ideas and feelings elude us which are in fact relevant. To Picasso African sculpture meant novelty of form and line. But that limited intake, which sufficed for his technical purposes, is the very thing that dehydrates much of the modern artistic experience, making it a game of forms and schemes. My authority for this complaint is Picasso himself. He often denied that the artist is only a talented organ of sight. He also protested against our prevailing use of art: "painting is not done to decorate apartments." And he concluded: "It is an instrument of war for attack and defense against the enemy." The upshot would seem to be discomfiture for all three parties—the formalist, the man who loves nice things, and the bedeviled social enemy. The profusion of styles tends to foster discontent instead of nourishing the spirit.

Notice as a further point that lacking a single style it is virtually impossible to have public ceremonies. The Greek and Roman and Medieval festivals caused no disgust and recriminations about style. Ours do, being either "corny" or "unsuitable." The French revolution managed fairly well, and so did the nineteenth century until 1848. After that the only examples of a gregarious style are the Rock camp meetings, and they are far from giving all parts of the population equal satisfaction. If any society wants a different state of things, it will have to demand it. I do not recommend the search for a communal art. I merely say that it is possible to do something other than encourage whatever offers itself and multiply whatever we already have. There may be such a thing as an Ecology of art. The great historian Nikolaus Pevsner made that point about architecture when he said: "The guardian of

131

the aesthetics of architecture is the architect. The guardian of the functional satisfaction is the client. . . . If out of muddle-headedness, out of laziness, out of initial ignorance, he fails, the building will be an annoyance, and the architect will (in my opinion wrongly) be reproached."

The difficulty is to know how "function" is to be defined and success measured in arts other than architecture. Earlier ages had more self-assurance. Lord Chesterfield, Dr. Johnson, Ruskin, Morris, Shaw knew what art was for and got many to agree with them. At the present time a number of contradictory positions occupy the field without generating public belief: under "formalist" tolerance, there are not even any instructive struggles between schools. The positions can be briefly put as follows:

Art better than life (a truer reality, a divine realm)
Art for a better life (revolutionary art)
Art for a natural life (spontaneous, primitive,
 improvisatory, disposable art)

If we classify by use rather than by aim or function, we get another triad:

Art a sanctuary for life
Art the enhancer of life
Art the detergent of life

Sanctuary and enhancement are roles played for us largely by the classics. Contemporary art deterges. The resulting choices are numerous and complex. If we adopt Picasso's formula of art as a weapon to fight the enemy and the enemy turns out to be the

public as a whole, the first question is how long the surgery—not to say butchery—ought to last. If we need to be shaken and shattered, if we go to the artist in order to face again and again what an enthusiast of Ezra Pound's called "his celestial sneer," then it is proper to inquire how the treatment is succeeding. The object presumably is to cure the beholder of his detestable complacency and materialism. (There is about this purpose a curious air of Victorian moralism, scarcely brought up to date.) Yet the cure is to offer him in visual or imaginative shape nothing but visions of deformity. He naturally identifies himself with the misshapen and the malcontented that (says Art) is the way he is. No doubt, but it ought not to cause surprise that the patient continues deformed and malcontent. Add the angry artist's will to humiliate as he teaches, and you perceive why the process has no end—or rather, it ends in a higher complacency, the complacency of the hopeless. Stubborn or shattered, the spirit resigns itself to its flaws and wounds after hearing them incessantly denounced as incurable. As between artist and society the conflict is a stalemate.

If the deadlock is to be broken, a moratorium will have to be declared on demonstrations of sin and guilt—or at least a little freshness introduced into the routine. The same holds for the related "lesson" that teaches the virtue of pure sensation. If the western world does not know by now that bright unmixed colors are wonderful, and subtle gradations as well; and if it does not know that words have resonances apart from meaning and that the mind is a stream of consciousness and that music started by knocking or rubbing objects together, it will never learn: it is a dunce not worth bothering with. Life is too short and art too long to carry the show any further with the same stance and grimace. It is more than 50 years since Breton and the Surrealists

133

held up placards advertising all this above the general greeting: *"Tas d'idiots!"* (Bunch of idiots!) How long are such idiotic idiots worth working over?

If the rejoinder is that these lessons have their use as exercises, keeping us in trim long after we have assimilated the idea, then the demand ought to be for a more lively textbook. The lessons have grown dull by overuse and some of the tricks were fatuous to begin with. The variations are particularly dreary. When an artist has earned a large fee in New York by digging a hole and calling it a sculpture, little advance can be seen in Munich, where a confrere fills part of an exhibition room with dirt. Concave and convex can be understood at less expense. Such lessons lack the ingredient found in the truly satiric imagination, the power of thought. Only lessons of fused intellect and imagination could exercise our minds by repetition.

As to the more elaborate onslaughts against things as they are, it is a general truth that they are always needed. A common title of old sermons was: "All stand in Need of Salvation," which meant that a weekly demonstration of sins and errors was proper and to be expected. But the general truth does not exclude a judgment of the qualifications of the sermon-writer on the point of doctrine. As I hope I made clear, the art-sermon of modern times has dealt with human conduct and human arrangements in a manner neither religious nor morally consistent. It has browbeaten the parishioners, without differentiating among their propensities and opportunities of sinning. Words such as bourgeois, materialistic, philistine, barbarian, complacent were used as if they accurately denoted removable malignancies. The treatment has gone on for decades in the face of evidence from other investigators which showed that few people were complacent and that most, on the contrary, felt guilty and insecure; evidence that the bourgeoisie

134

was divisible into widely different sorts of persons, historically and contemporaneously; evidence that materialism is a feeble abstraction which fails to distinguish the common appetites from the crassest cynicism about wealth and power—in short, few of those who trained their guns on society, whether as moralists or as revolutionaries, bothered to master the facts about the enemy, including his exact location. Usually they were too busy with their own technical problems in paint or words or stagecraft, for which we must honor them, as knowing where their best talents lay.

The result has been a massive output of art which took every means to avoid oneness of style and wound up pursuing by note one traditional intention, one enemy—the world, the Waste Land. Hence a certain logic in the disregard of accurate detail. Any instance, observed or made up, any allegation or imputation of motive was bound to be verified somewhere, as any stick will beat a dog. But if there remains in the public a desire that literature and the arts should criticize life, and not merely denounce it, then criticism through art must be held to the same standard as is required of criticism *about* art, that is: correspondence with the facts and the exercise of that rarest power of the mind which is called judgment.

After such a demand has been made—if it is to be made—the public has one further element to weigh in deciding what use to make of art for the purpose of social criticism. This element is the cultural temper of the majority. The masses do not want to exercise a critical judgment about life. They want life to be good and they are ready to see its pleasures enhanced by certain types of art, excellent in their kind. But they intuitively turn away from art whose aim is criticism. To say so is not to disparage their critical faculties; on the contrary, their attitude is that which art also tries to instill when it advocates simplicity, spontaneity, primitive pleas-

135

ure in form and sound and a quietus to self-consciousness. Out of the majority, in any case, comes the new genius, and the question is what his soul is to imbibe. Only the public for sophisticated art can decide whether he himself is to be sophisticated by contact with the prevailing establishment tradition of art-as-destroyer.

Meanwhile it is a fact that the continuity of civilization depends on the power of the majority to remain non-critical. Not that by being so the mass propels civilization forward, but that it preserves whatever is assimilable in sophistication, creation, criticism, subtlety, and the cult of the new. It insures such stability of life and survival of meanings as we enjoy. For it is obvious that if by magic, at every moment, all the new visions of art and philosophy and politics were immediately made actual, culture and society would be volatilized at once. Nothing would remain but a volume of superheated molecules, a gas.

At the moment, the commonest means of protection against the perpetually critical and destructive is to take refuge in the Interesting. The word and the corresponding habit of intake enable the public to defuse the bombs dropped and the mines laid for its daily annihilation. For it is annihilation, nothing less, when the public is made to feel that as it now is it has no right to exist; it is an even more stupid calculation when the playwright, dancer, painter, or mock-musician expects that anybody can be remade instantly under such a threat. Over the years the beholder has withstood the higher and higher voltage, and found that he can survive. He goes on with his business and earns the money with which to pay the higher and higher admission prices to a shock treatment that has become a habit, like church-going.

The damage is hidden, and until one looks for it the appropriate questions do not come to mind. The first is: if you substitute routine respect for belief—belief or disbelief—then you will have a

lukewarm spiritual life. As late as the *Sacre du Printemps* the au-
dience howled when it was hurt, stomped out when it was bored.
By the time, 50 years later, when Mr. Cage and his pupils per-
formed concerts of static from radio sets and girls danced past
photoelectric cells to start recorders going, the audience had be-
come *uniformly interested*. The doings were unexpected, ingen-
ious, new, and pleasantly perverse. But physiological excitement
had collapsed.

Without the visceral, art is indeed for art's sake, and not, as the
original esthetics clearly meant, for life's sake. Art for art's sake
literally means art made because there is a guaranteed consumer to
take it in, like the parish magazine. It is art made and distributed
because art is an institution of the status quo, the bread and butter
of thousands to whom it means—bread and butter. It is art ground
out as a bureaucracy grinds out paper. Avant-garde trappings do
not alter the mechanical gesture. If you should doubt it, test the
conclusion this way: in the late eighteenth century the Encyclope-
dist D'Alembert drew a striking parallel: the common people, he
said, go to see public executions for the same reason that the edu-
cated public go to see Tragedies on the stage—for the deepest
possible excitement. Are there today presentations of new art that
elicit such a response?—Honestly?—Where?

Making art an institution, as we have done; making surprise
and oddity a requisite, as we have done; responding faithfully, as
we have done and do—all have combined to deceive the modern
artist about his position in space and time. He knows all too keenly
that he may not succeed, that a living is hard to earn, and that the
struggle with matter and technique is never ended—in these re-
spects he is genuine. But he also thinks, I fear, that by virtue of
having left behind sweetness and light, he is at last working in
the right groove; no more softness, naïveté, romanticism, illusion,

137

hopefulness or any such folly clings to their work. No one will come after and call it silly. Poets today who use broken rhythms and what they regard as bold juxtapositions of sexual and machine-shop words would be greatly surprised to hear that they are the exact counterparts of genteel versifiers a hundred years ago, who wrote dilutions of Tennyson as fill-ins for magazines. Yet the parallel is extremely likely—almost guaranteed—the ones gave faded loveliness, the others give emaciated Interest, the original force of each long since departed.

There would be much to say about the effect of these later senti-mentalists on the reader's attitude toward life and love, among other private emotions. But the public effect of Interest by con-trived oddity and routine perversity is the more important. It can be stated as a reinforcement of the inversions that science pro-duces and social science imitates: you think this table top is solid matter—it isn't: the "holes" in it are bigger than the particles. You think you are looking at a star—well, what you see is light that left the star four million years ago. You think there is noth-ing in the Cosmos but matter? Don't believe it—there is anti-matter—just as there are novels and anti-novels. Common sense, in short, is always wrong. The parallel in art of this systematic contradiction accustoms the mind to believing only what defies experience. Only that is Interesting and worth discussing which possesses the peculiar quality of upsetting, inverting, upside-down-ing. However true and useful this may be in any given instance, as an intellectual habit, it is as mechanical and untrue as conven-tionality, of which it is but the mirror image. In a novel that won the Goncourt Prize in Paris and was published in this country last year, we are let into the theory behind the method: "Society offers each of us an emotional, professional, and even a sexual schema, and we are asked to remain faithful to it. . . . As soon as we leave

138

the schema dictated by society, perversion begins at once. What encourages us to be perverse or depraved? It is literature, in the degree to which it creates mythological characters." These words are clear and authoritative evidence of the system. It has become so regularized that the use of art for the defeat of convention does not even afford any longer the vengeful humor it used to arouse in the far-off days of Jarry and Marinetti; even the Surrealists and Dadaists of 50 years ago were the second-comers in a genre inherently short-lived.

The automatic use of these old twists by repetition is no less bad for the serious artist than for the public. His position becomes that of the commercial hack, who turns out his stuff by formula, knowing what is wanted. The price he pays is to despise his work and hate his audience and himself. But is not this sacrifice necessary to make the stupid non-artists somewhat more aware—not of art alone, but of all important things? This is the rationalization offered by the critics, who claim for the perverse both profundity and beauty—the second quality arising as a sort of after-image when the shock has been absorbed, the eye opened, the mind humbled. That might indeed be the result, provided the self-consciousness produced by the assault was assimilated, was buried in a new, unconscious, self-confident ability to deal with life, a true spontaneity, and not merely a tired recognition of the lesson. Genuine learning, whether physical as in playing an instrument, or intellectual as in doing mathematics, proceeds just so: awkward and excessive awareness is followed by a forgetting that leaves one in possession of a new power. How many of us today achieve anything like this enhancement, this athleticism of the spirit, through the discipline of contemporary art?

One clear sign—besides the universal groaning about existence —that nothing of the kind follows our heightened self-conscious-

ness is the tone of expert and lay discussion about art and artists. One example will stand for thousands and I take it, for fairness' sake, from among the most lucid and unhedging I have come across. Here is a painter describing his latest work: "A square (neutral, shapeless) canvas, five feet wide, five feet high, as high as a man, as wide as a man's outstretched arms (not large, not small, sizeless), trisected (no composition), one horizontal form negating one vertical form (formless, no top, no bottom, directionless), three (more or less) dark (lightless) no contrasting (colorless) colors, brushwork brushed out to remove brushwork, a mat, flat, free-hand painted surface (glossless, textureless, non-linear, no hard edge, no soft edge) which does not reflect its surroundings—a pure, abstract, non-objective, timeless, spaceless, changeless, relationless, disinterested painting—an object that is self-conscious (no unconsciousness) ideal, transcendent, aware of no thing but Art (absolutely no anti-art). 1961."

If one item of visual art calls for so much orientation by yeas and nays the area and density of the jungle can readily be gauged. When a period no longer has a style of its own, the first thing it loses in its relation to art is immediacy—including the immediacy of rejection. The beholder dare not reject, quite apart from social timidity, because he lacks any context for response. The artist may pretend that none is needed—invoking the myth of autonomy—but the beholder knows better and is confirmed by the fact that the artist felt impelled to write a long commentary in lieu of context. The words are not enough, while they are also too much. Most often they are words without meaning, words trampled into mere husks of thought by overuse, as they have been in advertising and the propaganda of fifty years of war. Even when they possess a certain clarity, they do not advance the cause of art or the understanding of the public, because they form no part

140

of any common world of discourse in which disagreement is possible. They belong only to one or another of the myriad "ideologies" of art, that morass akin to the endless interpretations of the Bible in the centuries of the Protestant Reformation: every man his own theologian.

Such confusions are never *dis*entangled, they are thrown away. A later generation, seeing that zeal for enlightening the world leads to increasing darkness, tosses out the archives of the whole event. It clears its mind of cant, makes itself a new mind, free and strong for fresh creation.

This, I think, is the point we have nearly reached—the point of total elimination, the last mighty effort in which every act and all its opposites converge to bring about the leveling of the ground, the wiping clean of the cultural slate.

If I am right, what we are witnessing in all the arts, and in all that the arts refer to, is the liquidation of 500 years of civilization —the entire modern age dating from the Renaissance. If this is true, then much if not all that we have gone over in these lectures can be understood—and rejoiced at. Great periods of art and thought have to come to an end. How do they do it? By exhaustion and self-destruction combined. Artistic forms wear out. Nothing more can be squeezed out of the intentions or techniques. After their full positive exploitation, the subtle art of allusion, parody, and inversion also gives out. There is then nothing to do except declare bankruptcy. That is the meaning of anti-art. The anti applies not to Art viewed as universal occurrence, but to the art we are familiar with and capable of. In our modern era, so rich historically, this means a great deal of art. The latest anti-novel by Natalie Sarraute is a superb allegory to this effect. It is called *Do You Hear Them?* The title refers to the laughter of a a man's children when the man, a serious art lover and collector,

141

has shown them with pride his latest acquisition, a piece of pre-Columbian animal art.

The novel—so-called—is not something Flaubert would recognize. It consists of short phrases and broken sentences separated by dots. You have to guess who is speaking and what the drift is. The drift is this: the children think it comical that their father could love an object more than life. It is perhaps a commentary on our mental state that this sound and rather obvious observation may not be presented to the public in just those fifteen words. It has to be crept up on in a 150-page book which flouts suspense and is not nearly so witty as the publishers say. The effort required to grasp the point of the riddle is also part of the exercise tending to the liquidation of art.

Let us look at the varied means by which this task is being done, beginning with anti-art. The target here is double; what is hit is both the high art of our tradition, which now seems so elaborate, portentous, and rhetorical, and the ideal of Esthetic Man—the man who before and after 1890 found in art a second world in which to feel and live. Art and the world ceased to be continuous; he suffered from mixed emotions and lost passion and belief altogether. Irony which is the great principle of modern art ended as the habit of perpetual self-contradiction, as in Brecht! When nothing can be affirmed, life loses its essential character, which is to make a demand and make it good.

Esthetic Man must be got rid of because he is all-devouring, like his predecessors, Political Man, Religious Man, Economic Man. They are all imperialists who want the entire cosmos drawn like a wire through their single keyhole. Esthetic Man destroys all other men—not alone his neighbors, but other possible men inside himself. The artist within each of us turns persecutor of civic man, man of affairs, social and sociable man, playful man, idle man,

142

and perennial man, who is forever mediocre, gross and blind to his surroundings. The last half century has artistified practical men out of their very natures. Their misery is symbolized by the ghastly word creativity, which all these poor gulls have seized on as the prize that life denies them. Every job must be creative. All schools fail that do not develop creativity in their children. The latest textbook on executive success solemnly recommends "mastery of ambiguity" on the pattern of the modern poets. Surely by now it is an act of mercy to extinguish Esthetic Man, and it is the very purpose of all the fooling arts—disposable, minimal, accidental, and junk.

As before, a word must be added about the uses of art for revolution. He seems like one to whom the external world is not blotted out by art; it exists for itself. But our word on this topic can be very brief, because the history of attempted union between art and political regeneration is that of total misunderstanding, radical incompatibility, and tragic failure. From Blok and Maya-kovsky down to Pasternak and Anna Akhmatov (to say nothing of the meanderings of Gide, Sartre and other westerners), the story of revolutionary art is one of shattered illusions. The dis-qualification of revolutionary art as such has been effectively done by its own most gifted practitioners and proponents.

One might say the same about those who produce works in the spirit of violence and contempt; for they are usually great talents constrained by history to do the work of demolition. With the millstone of experience around their necks, they cannot es-cape. The masterpieces of five centuries doom them to repeat or abdicate. Their enormous skill with paint or sounds or words is no longer usable. It would say nothing true or weighty. So they are forced by circumstance to make their works talk about art while maintaining their pretence to *be* art.

143

Hence these artists' hatred of the whole institution of art, beginning with museums and ending with critics and collectors. These gifted artists, potential creators, would surely destroy the artistic past physically if the police were not nearby, better able and more eager to catch artists than other criminals. In their exasperation there is nothing to do but use words to blacken the love of art, which the philistine freshly graduated from estheticism still pursues. Thus a woman novelist and her art-curator husband put together a smart book called *Fifty Works of English Literature We Could Do Without*: your favorite masterpieces are on the list, with reasons given for their elimination.

Vandalism, you say, and you are right. The common people feel the same need as our leading spirits and go to work on such objects as are within their reach—telephones, machinery, public facilities, sometimes a painting or a Michelangelo sculpture in St. Peter's. Everywhere the open surfaces of buildings and public vehicles are free space to advertise their scorn. Graffiti, which some highbrow opinion has quickly raised to the status of popular art, embody the profound desire to spoil the face of a civilization too much prolonged. Iconoclastic movements in the past may have had religious and philosophic motives—the hatred of images and ornate carvings for the sake of pure faith—but at bottom and for the majority there must have been also the eternal urge to smash what has been there seemingly forever, make room for the new. By instinct the child does the same, suddenly, with the building blocks he has so tenderly erected.

With us the recurrence is aggravated by excess. We have become gluttons for art and have lost all restraint about its uses. Already a century ago Berlioz spoke out eloquently against the overuse of music, which he said destroyed the whole art by insensitizing the listener. For great works especially, he wanted

144

times set aside for performances, which the intending hearers could contemplate in advance and prepare themselves for. What thunders would be unleashed today against use and abuse, when all the arts, and music foremost, pour down on us in an incessant barrage! The centers, schools, amateur groups, dealers, neighborhoods, trade-unions, businesses, broadcasters, hospitals, settlements, prisons, banks, universities, and foreign nations let loose upon us art of every kind, in addition to the regular establishments that once had the monopoly of production and display—museums, libraries, concert societies, picture galleries and publishing houses.

The distribution per capita is of course unequal, but that top-heaviness only increases the torment. For the relatively large group which is showered with these supposed goods, there is too much to sort out, let alone assimilate. Technology has multiplied the product, and those who were once users and choosers have become helpless flood victims. The hotel elevator dribbles Vivaldi into our unstoppable ears, just after the cab radio has interlarded gobbets of the Ninth Symphony with the driver's loud comments on the weather. All this is desirable Destruction. There is also too much to see—type and color and design—on the periodical page, the wall, the screen, the package, the morning mail. There are too many books, journals and reprints, newsletters, pamphlets and appeals, with graphs, photographs, illustrations, headings, diagrams, poems and prose. The Niagara of words is as inescapable as those other inflictions. Nothing ever gets less by reason of more bursting in another form; all merges together into a single medium with homogenized artistic properties, indistinguishable.

And all this, again, is destruction and future hope. It is the chopping up, the pulverization and dispersion of the classics, of their echoes and imitations. All these fragments out of place and

145

out of context, all the misuses and misunderstandings—*Macbeth* boiled down to 80 minutes, *Wuthering Heights* or *Tom Jones* on film, Leonardo on T.V., Rabelais staged in a few scenes, Shakespeare in the Park, humanities programs for the hinterland, sunrise semester for the culture-hungry before breakfast, digests and anthologies and all-you-need-to-know-about-art-in-one-handy-volume—all this wonderful, passionate, purblind effort of our disseminators achieves precisely the same thing as the transmogrification of Bach and Mozart into jazz and rock played at nosebleed levels of loudness. It accomplishes the painless stripping of signification and force from works once vivid and whole.

Criticism helps too by analyzing and re-analyzing until opinion also becomes a fine dust of disconnected particles. And just as repetition turns the noblest phrase into a senseless cliché and the greatest work into a dull warhorse, so the instant theorizing about techniques and fine points robs them of charm and makes novelty pass into oblivion faster and faster. Paradoxically, the speed of this kaleidoscope transforms the bewildering spectacle into the simplicity that has been so long looked-for elsewhere. The fragments that occupy our gaze or our ear are getting small enough to pose no problems of synthesis; their spent force arouses no emotional disturbance. Both are good reasons for giving up the pious formulas about the immortality of great art. What chance that disposable art will last forever? And now that technology is disembowelling traditional art, as I have suggested, *all* art is disposable, is right now being disposed of. The pincer movement is from above and below and sideways; the classics, the popular arts, and the contemporary are grinding down one another, which means everything in sight. If anyone sincerely doubts it, let him look at the social institutions inside which the arts function: the state, the school, the mores, the primacy of reason, the idea of the individual and his responsibility

146

—all these inherited forms are chipped and cracked and letting their contents drain away. The arts lead and follow the dance of death.

The natural question is, what is to replace them? Only a prophet can give an answer, not an historian—though the latter may permit himself to suggest some conditions, present or future, that will affect what is to follow. Clearly, the creation of a new art and culture will depend on the appearance of a new man, that new man whose specifications so many have already tried to give and to bring into being. The most naive efforts to alter present man such as painting the skin, turning the eyes into black smudges, and generally substituting the clown for the bourgeois, are indicative of a widespread impatience. The body should spur the slow mind, which cannot be so readily painted into a new design. Yet it is idle to talk of old and new consciousnesses as if they could be put on or taken off like garments. Nietzsche, who first broached the subject of a new man, made no such mistake. He knew that vast and unstageable events had to occur before new convictions could arise. The utmost that can be done by thought and will is to "take" such events in an indescribable new way, radically unlike the old; and for this some of the old attachments and objects must first disappear.

Hence the great importance of the cultural liquidation I have tried to describe. When certain objects vanish, or certain delights associated with them, there is no longer any way of "taking" them at all. Suddenly, the consciousness finds itself free; the bereavement is a relief. At that point the creative powers, formerly oppressed by tradition, by lingering pleasure, by social coercion, regain their primitive strength. It is only a question of having a sufficient concentration of individuals endowed with such powers. When it occurs, we call it a revival, a renascence.

147

Meanwhile the use of abuse we make of art impels us, as individuals forward or back. If seeing the confusion for what it is, one keeps on adoring art as an unconditional good, this well-meant dishonesty will retard both individual and society. Again, if one lives in a vacuum of belief as one can hardly help today, one need not on that account share the common fear of entertaining a belief as such. For example, it would be a new and perhaps a fruitful position to say on some appropriate occasion: "It is because I understand this work of art that I dislike it." That alone would reverse 100 years of high-minded hypocrisy.

Similarly, any perspective gained from knowledge and feeling should lead to some change of conviction and result in its being expressed. I have told you how it was that my exposure to the arts of the Cubist decade made me see clearly how un-modern, uncontemporary a large part of our artistic output now is. I understand why it is so, but I decline to condone repetition and beam upon it as if it were originality. I condemn the past and condone the present, if you like, in the name of the future, believing as I do that all we mean by art and do with art today is past and over-past. My possible error does not and should not alter my testimony. Art is of all subjects the last on which one should defer to the judgment of the crowd, even a crowd waving paint brushes or T-Squares in their hands.

At the same time, it is permissible to observe a difference between one's general conclusions and one's private predilections. What I see and infer makes me reconciled to sing a Requiem for high art, convinced as I am that the grand Renaissance conception of high art is no longer alive. But the Requiem I want to hear from my own pleasure at home and with friends is the Requiem of Mozart or the Requiem of Berlioz, in whom that conception

was still alive and potent. There is no contradiction and my kind attention to myself will not delay the advent of the new man.

So far I have suggested some of the conditions of his arrival which we can foster by taking thought, by choosing and acting on what we feel and want. The larger conditions, out of our control, derive from historical tendencies long at work. They could be summarized this way: the Renaissance created Man the Measure. For him the universe was limitless and man also. The Reformation fought for and won freedom of mind and spirit. The world willy-nilly became the battleground of opinion, until pluralism was deemed one of the pleasures of the moral and artistic life. Finally came the Revolution, French and other, and it decreed Equality, which came to mean the good society, founded on bread and joy for all.

Under the impact of the last of these three ideals, the first one necessarily retreated. The simple evidence is that character-drawing—that typical Renaissance invention found in fiction, plays, and lyric poetry for five centuries—has lost its magic and disappeared from literature as it largely has from life. We may reasonably suppose, therefore, that the new man and his art will not be individual—at least at first—but communal. Art will undergo a return to the medieval pattern; a literature of low intensity, paired possibly with a monumental architecture, in which the figurative arts will find an organic place. What function and what form the new man will choose for art from the infinity of the possible, nobody can tell; if one could tell, it would not be a new art; and if really new, it would not be intelligible to us now, or congenial. One thing alone can, I think, be predicated of the spirit in which the new man will work. He may remember our deep resentment of the human condition, but having really got rid of our

149

now repetitive culture, he will take the facts of life differently; he will say something like the old Greek poet Pindar: "The gods give us for every good thing two evil ones, and men who are children take this badly. But the manly ones bear it, turning the brightness outward."

Library of Congress Cataloging in Publication Data

Barzun, Jacques, 1907-
 The use and abuse of art.

 (Bollingen series, 35. The A. W. Mellon lectures in the fine arts, 22)
 1. Arts and society—Addresses, essays, lectures. 2. Arts, Modern
—20th century—Addresses, essays, lectures. 3. Arts and religion—
Addresses, essays, lectures. I. Title. II. Series: Bollingen series, 35.
III. Series: The A. W. Mellon lectures in the fine arts, 22.
NX456.B38 700 73-16780
ISBN 0-691-09903-0